Learn to Paint

Pastels

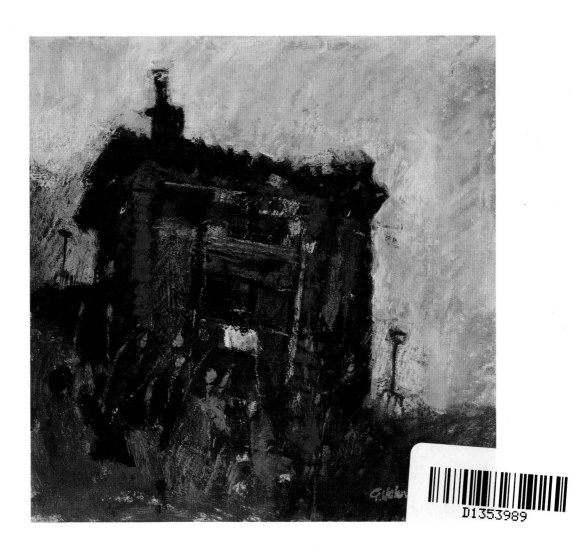

JOHN BLOCKLEY

First published in 2001 by
HarperCollins*Publishers*
77-85 Fulham Palace Road
Hammersmith, London W6 8JB

The HarperCollins website address is:
www.**fire**and**water**.com

Collins is a registered trademark of HarperCollins Publishers Limited.

01 03 05 04 02
2 4 6 8 7 5 3 1

© John Blockley 2001

Editor: Patsy North
Designer: Caroline Hill
Photographers: John Simmons and John Bouchier

ISBN 0 00 413405 2

Colour reproduction by Colourscan, Singapore
Printed and bound by Printing Express Ltd, Hong Kong

Previous page: **Allotment Hut** 18 x 18 cm (7 x 7 in)
This page: **Autumn** 43 x 51 cm (17 x 20 in)
Opposite: **Yorkshire Landscape** 44 x 66 cm (17¼ x 26 in)

Contents

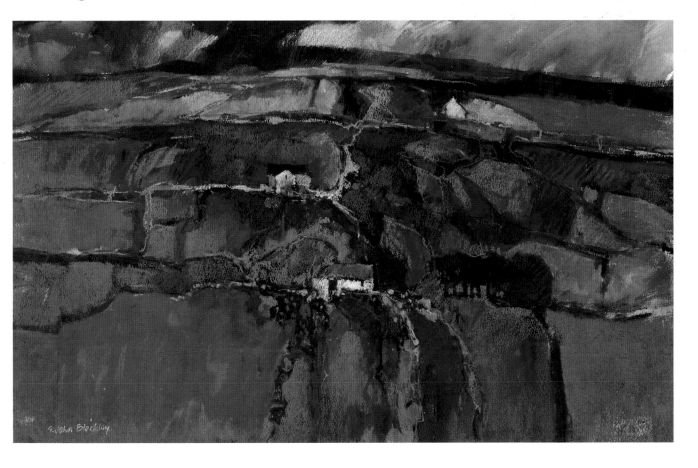

Portrait of an Artist

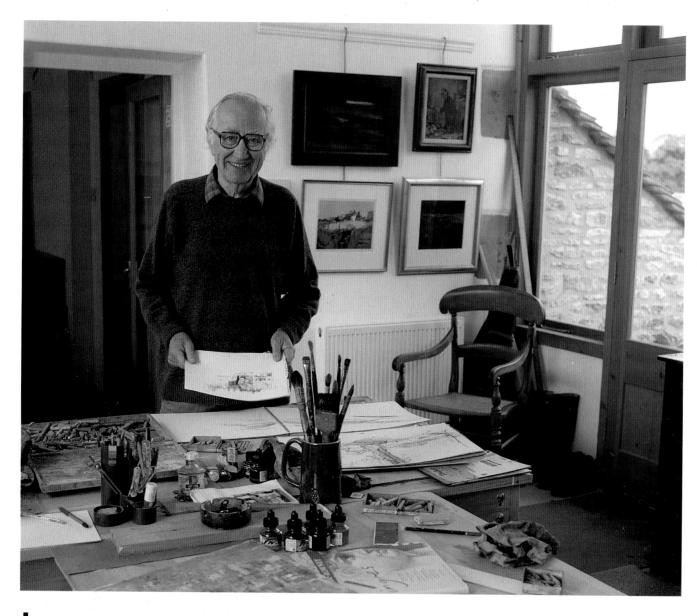

John Blockley was born in Knighton, Shropshire, on the Welsh border, and for some years lived and worked in the north of England. He now lives in the Cotswolds in a house with a studio, converted from old stone farm buildings looking over the village of Lower Slaughter.

John sums up his attitude to painting as a continuing exploration, and he is always looking for new ideas and interpretations. His work is based on constant observations of everything around him. He is not interested in merely a photographic likeness of the subject, whether it is a landscape, people or buildings. Nor is he concerned with distortion or contrived effects. His interest is in seeking out some special mood or quality of the subject, such as light, the surface textures of buildings, or the patterns of rocks, the ground and tree trunks.

▲ John Blockley in his Cotswold studio.

These interests have evolved through many years of painting landscapes throughout Britain. While living in the north, he painted mostly large landscapes of mountains, moors and industrial subjects, but also small, intimate studies of corner shops and shoppers with their baskets. He deliberately moved to the Cotswolds to work in a new environment, leaving an area where he was completely settled. He now paints the mellow Cotswold buildings, the woodlands and the rolling landscapes of the upper wolds.

John's work is widely sought after – there is always a demand for his paintings in the few selected galleries where he exhibits. His paintings are in collections the world over. He is a Member of the Royal Institute of Painters in Watercolours, the Royal West of England Academy, the New English Art Club, and the Pastel Society, of which he is a past President.

▼ John at work on a pastel painting.

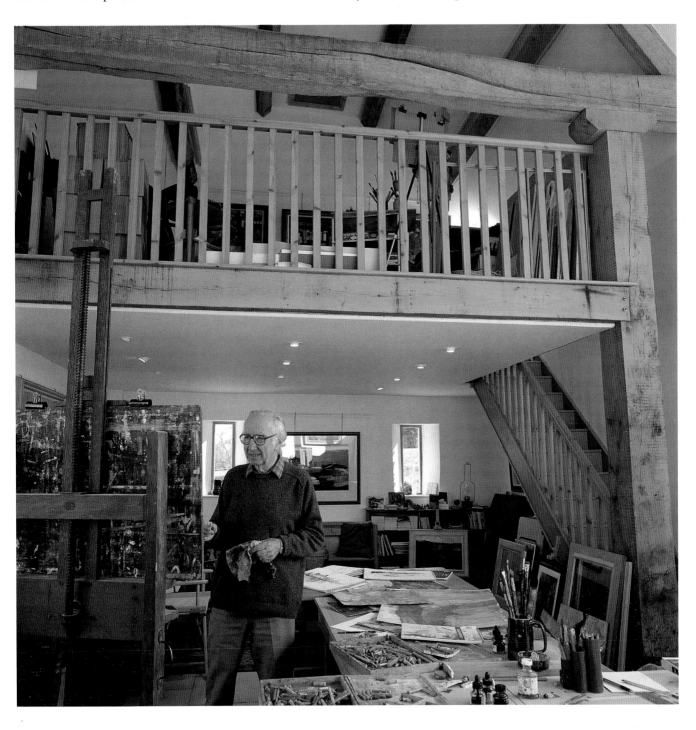

Understanding Pastels

Pastel painting can be as colourful and vigorous as any method of painting. Its powdery surface increases the refraction of light, so pastel paintings emit an intensity of colour unchallenged by any other medium.

Because it is a dry medium, there are no frustrations of waiting for the paint or paper to dry. It is dry paint – just pick up the pastel and apply colour directly to the painting surface. It can outlast oil paint, because it has no oil or varnish to yellow and crack with age.

An exciting medium

In addition to these technical advantages, pastel is an exciting medium. Most people are attracted to the paintings of ballet dancers by Edgar Degas (1834-1917), but might not realize that many of them were made with pastels. Degas, probably more than any other artist, exploited the special properties of pastels, producing paintings that seem to vibrate with colour. His painting *Dancers in Blue* was worked in 1890 and is typical of his way of handling pastels. It shows a group of dancers dressed in blue and set against a rich, tapestry-like background of brilliant splashes of orange and red. Because pastel is dry, Degas was able to apply colour over previous colour with short, quick strokes, dashes and dots of pastels, so that the colours underneath showed through.

Another of Degas' favourite subjects was racehorses, and these paintings are full of movement, rippling grass and reflecting light. This movement of colour and light is apparent in all his paintings, whether they are figures, interiors, landscapes, beach scenes or big skies. To me, Degas demonstrates more than any other artist the possibilities of the pastel medium.

Pastel painting in its present form dates back to the eighteenth century, although chalk drawings were made on cave walls in

▼ **North Yorkshire Farm**
61 x 107 cm (24 x 42 in)
This is one of my favourite arrangements with buildings on the skyline and plenty of interesting foreground texture.

◄ Mid-Wales
51 x 64 cm (20 x 25¼ in)
I was excited by the
wonderful array of colours
in this landscape and
captured these with
loose strokes of pastel.

prehistoric times. Pastel paintings more than
200 years old are as bright and fresh today as
they were when they were first painted.

Pastels require no more protective
treatment than that given to any other type
of painting. The best way to frame a pastel is
under glass, with a surrounding mount or
narrow fillet between the pastel surface and
the glass to prevent the glass from rubbing
against the picture.

What are pastels?

Many people do not realize that the pigments
in pastels are exactly the same as those used
for oil and watercolour paints – the difference
lies in the manufacturing process. Oil paints
are made by mixing finely ground pigment
with oil; watercolours are made by mixing
pigment with gum; and pastels are made by
mixing pigment with chalk and water to make
a stiff paste. After checking the colour, and
adjusting it if necessary with extra pigment,

the paste is pounded to remove air and
formed into long, round strips, which are cut
into short lengths of pastels. Once they have
been dried, the pastels are individually
labelled and carefully boxed to avoid damage
while in transit.

Most manufacturers incorporate a binding
material to hold the powder together in short
sticks. The quantity of binder in the mixture
can affect the strength of the finished product
and the quality of the pastel's mark. Daler-
Rowney are one of the few manufacturers that
use a process of making pastels without a
binder, which accounts for the durability and
softness of their pastels.

The strength of the colour in a pastel is
determined by the amount of chalk that is
mixed with the pigment. A lot of chalk will
produce a pale tint, while a little chalk will
give a dark tint, so there is a range of tints
within every colour. Daler-Rowney pastels are
graded from Tint 0 for the palest up to Tint 8
for the darkest.

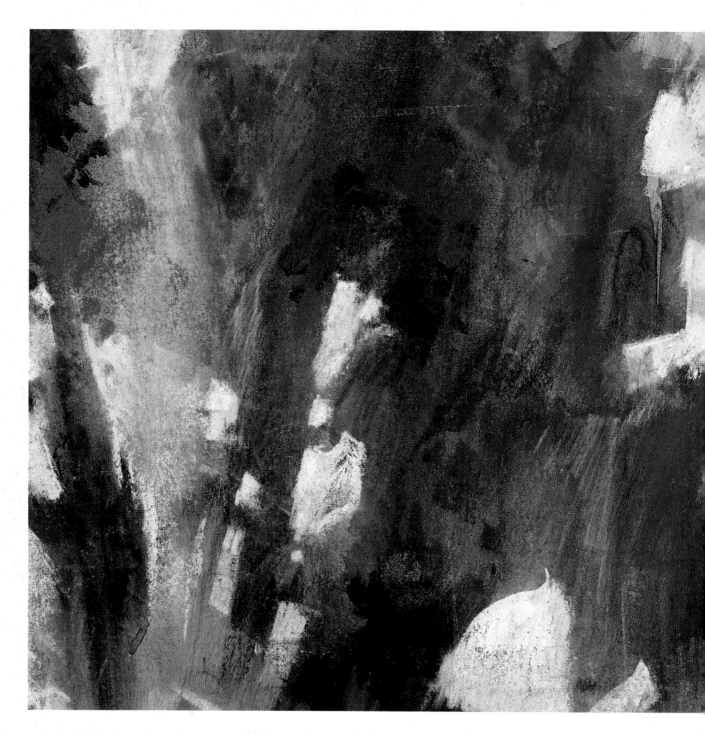

I selected the painting of irises (opposite) to show the effects that can be obtained with pastel. The detail (above) enables you to study the pastel marks more closely.

At first glance, the painting has a soft, atmospheric appearance with the colours merging together and with many of the outlines softening into the background. On closer inspection, however, you can see that the painting is actually a combination of these soft effects and contrasting hard edges – a technique described as 'lost and found'.

The vase emerges out of the foreground and becomes firmer towards the rim and the handle. The edges of some of the flowers are crisp and angular, while others are softly diffused, losing themselves into the background. The painting relies on this balance of softness and hardness, which is exactly what I wanted to achieve.

▲ Detail of **Irises**

▶ **Irises**
76 x 53 cm (30 x 21 in)
The flowers form one big mass of diffused colour with glimpses of magenta appearing out of the blues and greys.

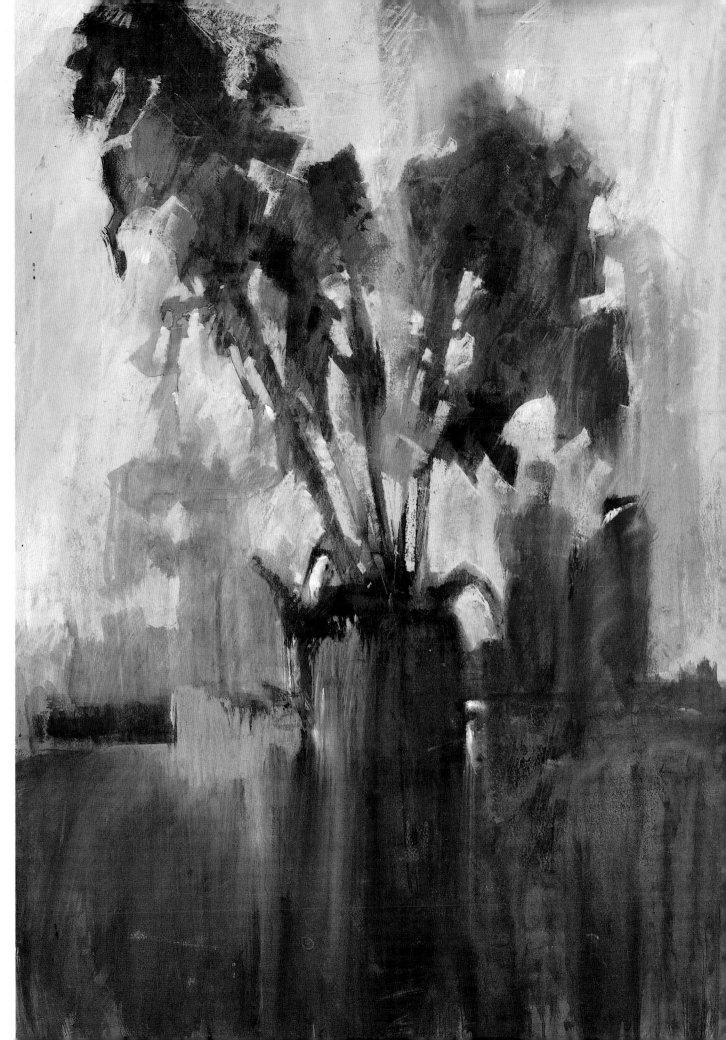

Materials and Equipment

One of the advantages of working in pastel is that you do not need a great deal of equipment. Your basic requirements are simply a selection of pastels, a suitable pastel paper, a drawing board and probably an easel. You will also need a few drawing materials to make initial sketches and rough out your compositions.

In this chapter, you will find out how to choose and store pastels and how to handle pastel paintings, as well as learning about the advantages of different types of easel. More information about paper and other supports is given in the next chapter.

Pastels

I am often asked how many pastels are necessary to produce satisfactory paintings. I think it is helpful to have a generous assortment, because it is very frustrating to find while you are painting that you haven't got quite the right tint. You would have to compromise and use the nearest tint you have, or adjust some of the colours you had already used on the painting, or mix the required tint by laying one colour on top of another. For example, you can make a pink tint by covering red with white pastel.

Pastels are usually stocked in the shops in two ways – as boxed selections or as individual pastels. Boxes come in varying sizes, containing as few as 12 pastels or more than 100. There are also selections available specially for landscape or portrait painting.

Individual pastels are usually displayed in trays, so you can see a large number of tints at a glance. They are a picture in themselves! You should select your pastels from the trays by the appearance of the colours, not by their names. If you should need to order some by post, the names will give you a good idea of colour

▲ A selection of pastels in some of the wonderful colours available.

subtleties, such as Blue Green, Yellow Green, Olive Green, Purple Grey and Purple Brown.

You will probably wish to begin with a modest selection. A basic selection should include Yellow Ochre, Coeruleum, Cadmium Red, Red Grey, Purple Grey, Green Grey, Warm Grey, Sap Green, Burnt Umber and Indigo. You will need a light, middle and dark tint of each colour. Remember that the lightest tint is Tint 0 and the darkest is Tint 8.

Identifying pastel colours

New pastels come wrapped in a paper band bearing the colour and tint number. Most of your painting will involve dragging the side of the pastel over the paper, so you need to remove it from its wrapping and break off a piece to work with. Make a colour reference chart by rubbing each new pastel on to a sheet of paper and writing the colour name and tint next to it. Otherwise, you will need to replace each piece of pastel in its wrapper, so that you can identify it when you need to reorder.

▶ A studio easel is ideal if you prefer to work standing up and the ledge is useful for holding the pastel sticks.

Storing pastels

You can buy special boxes that include a plastic corrugated tray to hold the pastels. These are useful for storage purposes and you should form the habit of always returning each pastel to its place after use. You could also mark each corrugation with the details of its colour. Some painters make their own containers by lining a shallow box with corrugated cardboard.

Another method is to have a small tin box for each colour – one for your greens, another for yellows and so on. By keeping all tints of a colour in one box, you are able to compare them quickly and select the particular colour and its shade.

If you store different colours in a box, it is useful to fill the box with ground rice. This prevents the pastels from rubbing against each other, and the slightly abrasive quality of the rice will keep the pastels clean. The rice should be sifted away when you want to use the pastels, and replaced after use to perform its function again.

I must confess that I am untidy in this respect. I just leave my pastels lying on the table while I am working, all colours mixed together, but I am sure it is better to cultivate a more methodical way of working. I think it is a matter of temperament – I am too impatient to be tidy and work in long bursts of feverish activity. If I don't immediately recognize a pastel lying on the table because it has rubbed against others, I rub it on the nearest piece of cloth. This is usually my shirt. I do not recommend this practice. You should work out some way of storing pastels and establish a method of working so that you can quickly identify the colours you want.

Easels

I stand when I am working, because I feel restricted if I try to work sitting down. I like to move about and be able to step back and look at the work instead of always having it under my nose. I walk about and return only half a minute later with a fresh eye.

I fasten my paper to a piece of stout hardboard with bulldog clips. It is sensible to put a few sheets of uncreased paper between the pastel paper and the board. This gives a pleasant, cushioned surface on which to work and also prevents imperfections in the board being transmitted to the pastel. I usually support the board at eye-level on an upright studio easel, but a portable sketching easel is equally suitable and can also be used for outdoor work.

Another advantage of using an easel is that I like to have the painting upright so I can stand away from it and work at arm's length for rendering broad sweeps of the pastel, and be able to step up close for detailed areas. Should the pastel crumble when I press too firmly on the painting surface, the particles fall and collect in the ledge on the easel, instead of adhering to the painting. An easel also reduces your chances of accidentally rubbing against the painting.

If you are less restless than me, or if you prefer to sit while working, a portable easel can easily be adjusted to a suitable height.

Alternatively, you can use a table easel, which can be tilted to various angles, or you can simply lean the painting against a pile of books.

Useful extras

Before I begin on a pastel painting, I draw the subject, sometimes with a pencil, sometimes with black drawing ink or medium-grade charcoal. The charcoal gives a black line of a texture and nature sympathetic to pastel painting. When you are satisfied with the drawing, you can flick the charcoal with a duster and leave a grey impression over which you can work in pastel.

If you make mistakes in your charcoal drawing or your pastel painting – and we all do – you can easily erase them with a putty rubber. This is a soft rubber that can be kneaded into quite a fine point and it will erase pastel cleanly, back to the paper. A painter's stiff hog brush is also useful for removing pastel, so mistakes in a painting can conveniently be erased without affecting the surface of the paper.

▼ Some of the other materials that you might need when working in pastel, including charcoal, coloured inks, paints and brushes, a putty rubber and fixative.

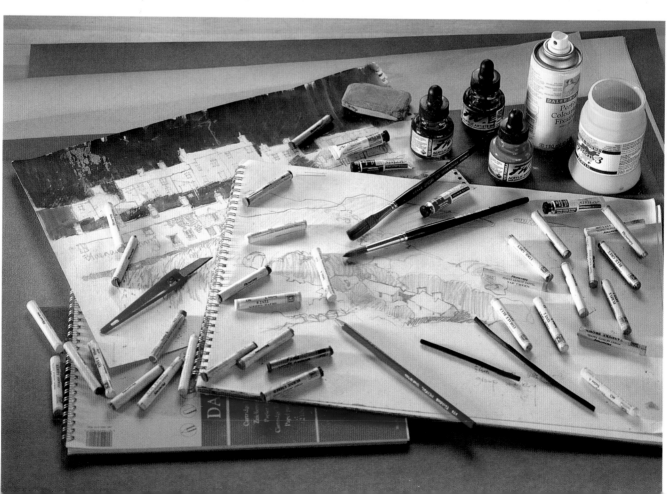

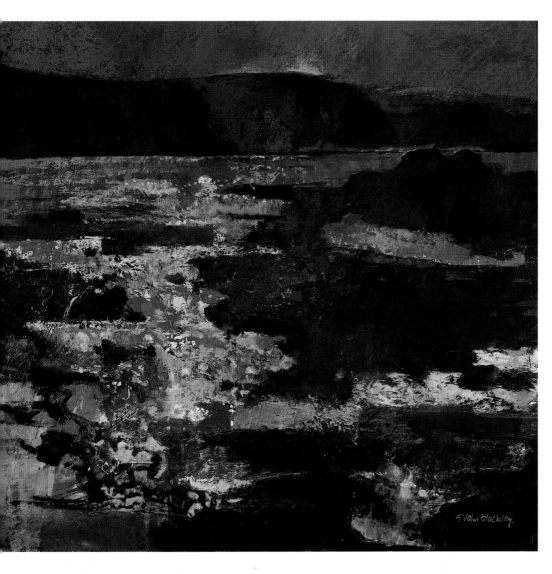

Handling pastel paintings

There is a lot of exaggerated fear about pastel paintings getting smudged. If they are treated carelessly, the pastel will smudge, although the paintings I made for this book were handled many times before they appeared in print. It is sensible to take reasonable care of paintings and not slide one across the surface of another. They can easily be stored in a stack, each one separated by a piece of tissue or sheet of newspaper.

Loose pastel fragments are sometimes dislodged from a finished painting if it is bumped or dropped. You can guard against this by spraying your paintings with a colourless fixative. This comes either in bottles or aerosol canisters. If too much spray is used and the pastel becomes very wet, it will lose some of its brightness.

If I have used a thick build-up of pastel, I often paste the finished work on a piece of mounting board. I place the painting face down on a clean table, brush synthetic wallpaper paste on the back of the paper, and leave it for ten minutes to soak in and to stretch the paper. Then I pick up the painting and turn it on to the mounting board so the right side faces up. I cover it with a piece of newspaper and smooth the paper down with my hand, working out from the centre, taking care not to let the newspaper slip. The paste tends to soak through the paper and helps to fix the pastel. A sheet of paper pasted to the back of the mounting board will prevent it from buckling as the painting dries.

Which Paper?

Some pastel artists paint on hardboard, muslin-covered board, canvas or sandpaper, but most painters work on tinted papers made specially for pastel work. The most popular are Canson Mi-teinte, Fabriano and Ingres. The only way to find out which of these suits you best is to try a variety.

The nature of the surface also has a significant effect, some papers being smooth and some rough. The texture of a rough paper will break through the applied pastel so that the colour of the paper shows through the pastel to give a broken colour effect, whereas this is less pronounced with a smooth surface. You will find that Ingres paper has a pleasantly sensitive surface to work on.

Once you have experimented with various papers and gained experience, it is interesting to try other surfaces such as conservation grade mountboard. This type of board is normally intended as a 'mount' with a cut-out opening to surround a watercolour, but I very much enjoy painting on its hard surface.

◀ Here, pastel is applied to the rough side of pastel paper. The grain of the paper is very pronounced and is too regular and mechanical for my liking, but many accomplished painters enjoy it.

◀ When pastel is applied to very fine sandpaper, it gives a lightly broken pastel layer or, with more pressure, a flat, dense surface. Sandpaper is quite popular to work on, but doesn't appeal to me.

▲ This example shows pastel applied to the smooth side of pastel paper. You can achieve a range of pastel surfaces depending on the pressure you use. With a light application, some of the paper shows through the pastel, while very heavy pressure tends to fill the grain of the paper.

Paper tone

When you are choosing a paper to work on, think about its tone – its lightness or darkness – as this has considerable importance in pastel paintings. Dramatic effects, such as a brilliant light in the sky behind a dark mountain, can be obtained by using light pastels on dark paper, for example.

I have discovered over the years that I can work best with a mid-tone paper – one that is not too light or too dark. I use this mid-tone as a starting point against which to judge the tone of pastel colour I want by determining whether it should be lighter or darker than the paper. A mid-tone paper can also reduce the amount of work, since a fair-sized part of it can be left uncovered.

Although a mid-tone paper is a good starting point, a dark paper can be a better choice if your subject is generally dark. As you progress through this book, try to be constantly aware of the significant role played by the colour and tone of the paper on which the paintings are worked.

Paper colour

The colour of the paper plays an important part in producing a painting. A cool grey paper, for example, will give a pleasing background to a painting composed of pink and green colours, creating a restful atmosphere. On the other hand, brilliantly coloured pastels will make a striking picture when painted on brightly coloured or very dark papers.

An exciting combination is to work on paper of a complementary colour. The term 'complementary' applies to a colour opposite another on the colour wheel, such as red on green, purple on yellow, orange on blue. A green landscape painted on green paper would be a gentle, easy-to-look at painting, whereas green pastel on a complementary red paper would make a more vibrant, energetic kind of painting.

Experimenting with a variety of papers and boards is enjoyable and constructive. By combining pastels with different paper colours and tones, you will discover how quiet and subtle, or vibrant and exciting, pastel painting can be.

Using grey paper

The barns shown on this page were taken from my sketchbook and are a good example of how a neutral grey paper can stand for the main colour in your subject and also help to convey an atmosphere. I chose grey paper for this scene because this was the colour of the barns and also because the grey suited my remembered conditions of the day – grey and moody. These two sketches show the progress of the work and demonstrate that hardly any pastel work is

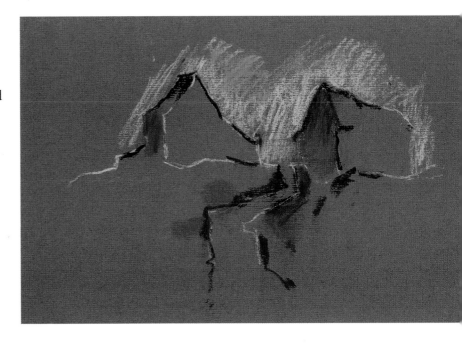

▲ Step 1

required on the barns. The colour of the paper did the work for me!

I began the sketch by outlining the main features – the barns and the path – before applying the main body of colour (step 1). I went on to develop the sky and the foreground (step 2).

All that remained was for me to continue the colours to the edges of the paper. The grey paper was left unpainted to form the colour of the path and barn walls. It also provided the mid-tone for the picture.

▼ Step 2

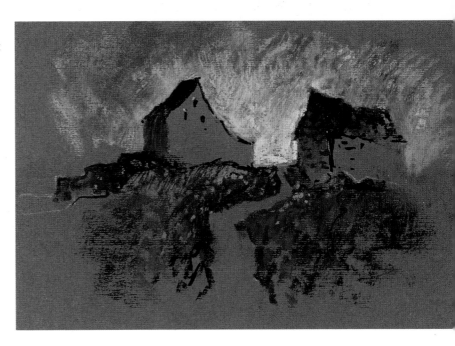

▼ Landscape, Wales
17 x 23 cm (6¾ x 9 in)
I painted this simple
landscape on green paper,
leaving some parts
uncovered, even in the sky.

Using green paper

Green pastel paper is an ideal background for landscapes, providing an additional colour for hills, trees or fields. By allowing the colour to break through the pastel in places, you can achieve unity in your painting.

▲ Step 1 ▼ Step 2

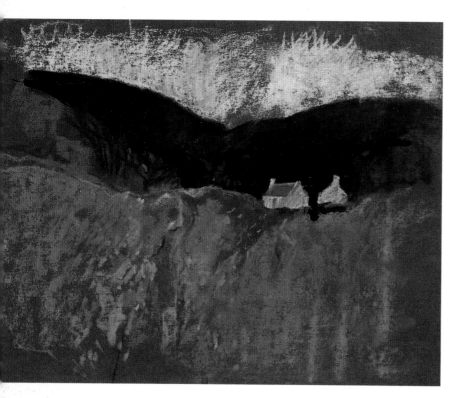

Colouring your own paper

Although pastel paper is produced in a range of colours, I frequently prepare my own coloured surface by painting paper or mountboard with washes of watercolour, gouache or acrylic. I vary the colour to suit each part of the subject – blue for the sky area, green or red for the grassed area, and so on. Daler-Rowney FW Artists' Acrylic Inks, which are lightfast, have interesting colours that I occasionally incorporate.

This process is sometimes frowned upon. However, I argue that if it is permissible to paint on an all-over green paper, it should be acceptable to work on a paper that is partly green, partly blue or red and so on.

The painting of mountains shown here demonstrates this approach. I applied quick, fairly crude washes of watercolour– blue on the sky, black in the middle and red in the foreground – to provide background colour on which to work (step 1). Once the washes were dry, I applied pastel over them, using reds in the foreground and blues in the sky and mountain (step 2).

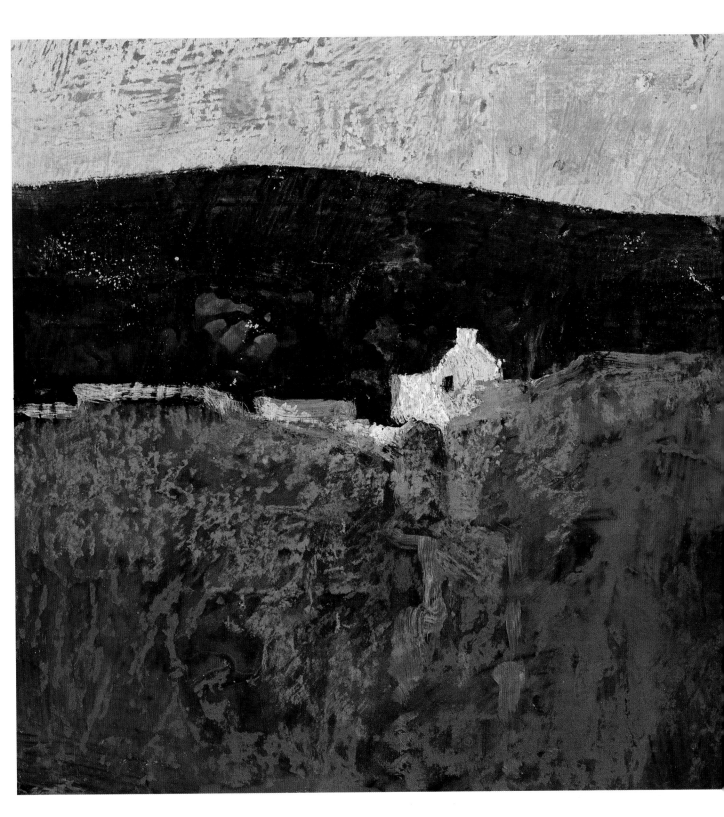

Using a single colour to provide a base for your pastel work is also very effective. If you leave suggestions of the colour showing right across the painting, it becomes an integral part of the composition, adding subtle or bright touches as required.

▲ **Cottage, Wales**
18 x 18 cm (7 x 7 in)
For this landscape, I first painted the paper with orange acrylic and then worked on it in pastel, using white in the sky and building and green in the landscape. Fragments of the orange base colour are visible, which resulted in a vibrant finish.

Making Marks

Pastel is unique in that it is a dry medium. You pick up a piece of pastel and apply it directly to paper without having to squeeze it out of a tube and mix it on a palette, as you would with watercolour or oil paints. This directness of application is exploited by many painters to achieve a sense of immediacy and vitality in their work. On the other hand, the medium is capable of quiet rendering, sensitive and discreet.

Basic strokes

The basic strokes employed in applying pastel are shown on the right. They start at the top with simple lines drawn with the end of the pastel, some with little pressure on the paper to create a thin line and some with heavier pressure to make a thicker line. The dots are produced by stabbing the end of the pastel on to the paper surface.

The wider strokes below are made by holding the side of the pastel flat on the paper and drawing it along the paper surface in the direction of the arrows. Variations in pressure on the pastel produce differing areas of density, heavy pressure filling the grain of the paper and lighter pressure allowing the paper to show through.

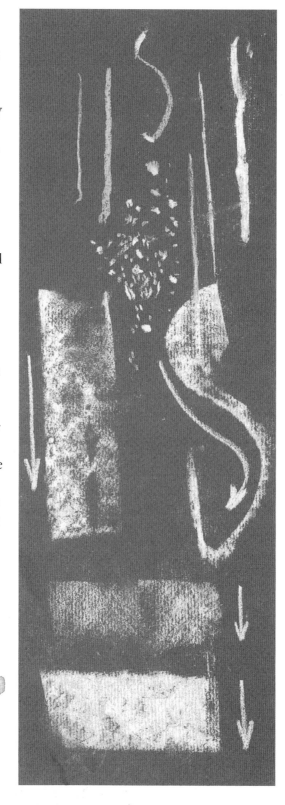

◄ These marks form the basic processes for producing paintings in pastels. They show lines, dots and broad areas of pastel applied directly to the paper.

Vary the density of pastel colour with hatched and cross-hatched lines. Place the lines close together for dense colour, further apart for a lighter effect.

Mixing colours

Mixing of colours is done directly on the painting by applying one colour over, or alongside, another colour. For example, a particular choice of green might be achieved by applying strokes of yellow over strokes of blue pastel. Some painters would blend these two colours by rubbing them together with the finger, while others prefer to leave them unrubbed so that the two colours are optically mixed, i.e. they appear to the eye to make a third colour. Look at the techniques shown on these pages and see, too, how they are used throughout the book.

Combining marks

I believe that one of the most enjoyable experiences in painting is the physical application of the paint. This is particularly so when manipulating pastel. It is a very satisfying process to create combinations of marks, such as broad strokes, narrow lines and dots, so that they blend visually.

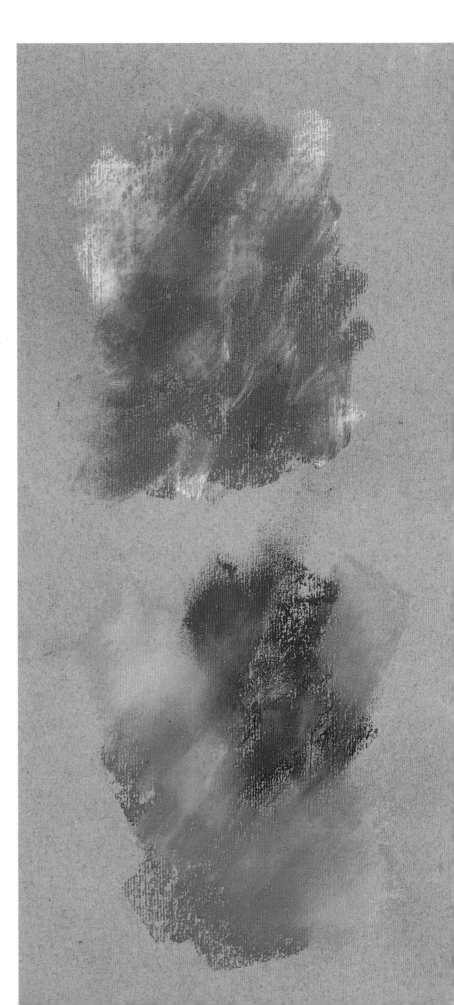

▶ In the first example of colour mixing (top), I used the side of the pastel to apply scattered areas of white. I then added red, sometimes on the uncovered paper between the white areas, sometimes on top of the white. By rubbing the pastel colours with my fingertip, I blended them together. In the second example (bottom), I repeated the process, this time using four colours.

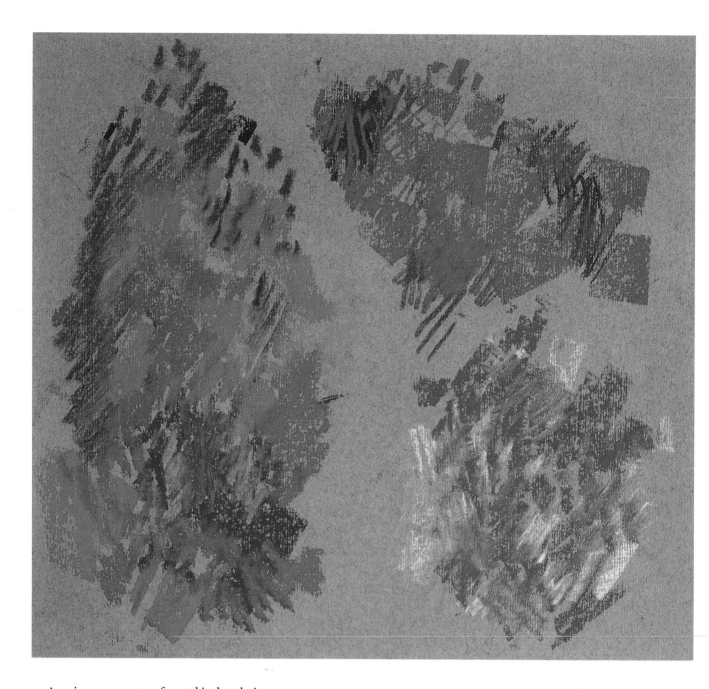

A unique property of pastel is that, being a dry medium, minute fragments of solid colour are deposited on to the painting surface. If left undisturbed and not rubbed, these reflect the light falling on them to create a vibrancy and luminosity unequalled by any other medium. It is important, though, to paint some parts of a picture less vigorously to avoid an overly busy surface. You can employ a different degree of energy in pastel work by putting less pressure on the pastel sticks, making shorter, thinner strokes or using just a few closely related colours.

▲ These unrubbed pastel strokes combine lines made with the end of the pastel, broad bands made with the side of the pastel, and dots of pastel stabbed on to the paper.

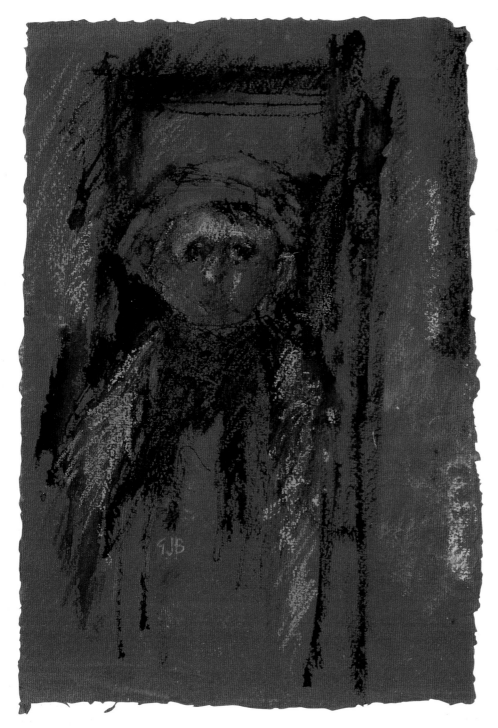

◄ **Boy with Red Hat**
29 x 21 cm (11½ x 8¼ in)
I painted this rapid sketch
on red paper, using only
a few pastel colours and
leaving large areas of the
paper showing.

There is always more to be discovered with pastel effects and I often end a day in the studio by dashing off a small sketch in colour, just to wind up my painting activity with a quick experimental piece. The picture of the boy with the red hat (above) was painted on a piece of rough red watercolour paper. I started with the black background, which enclosed and defined the shape of the figure. I then filled in this shape with a variety of marks to suggest the hair, face and blue scarf. Finally, I added a few smudges of black to define the figure further, leaving the red paper to stand for the coat.

Notice how the colour and texture of the paper contribute significantly to the sketch. The paper is handmade and has deckled edges and an irregular surface. These characteristics go well with the unrubbed pastel marks to give plenty of textural interest.

21

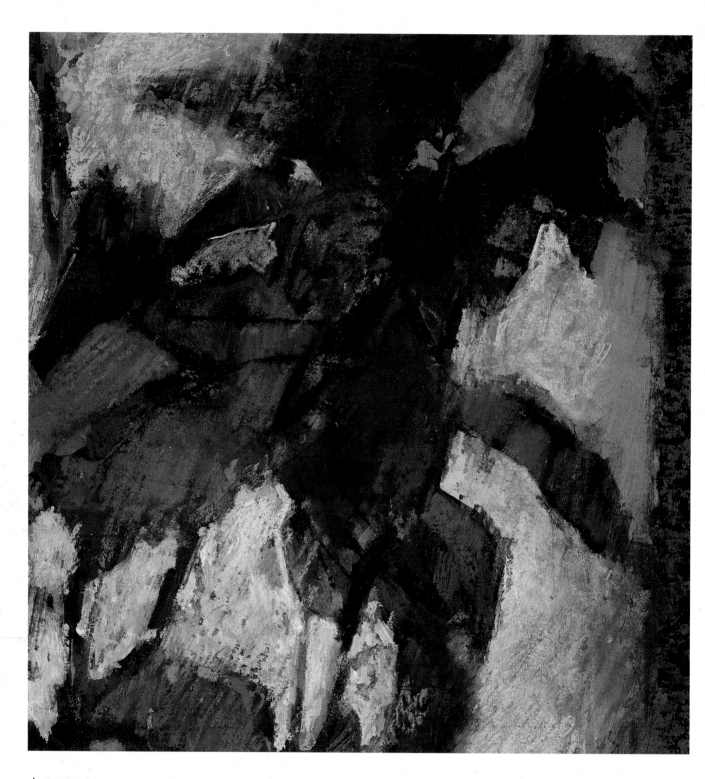

▲ This detail shows the energetic handling of the pastel work in the painting opposite and enables you to see how the colours have been built up with overlaid pastel strokes. The variety of lively textural marks on the flowers, leaves and background emphasise the vitality of the painting. Dashes of orange in the flower centres add a scattering of highlights across the picture.

► **Irises**
69 x 50 cm (27 x 19½ in)
I painted the flowers and vases with closely related colours in the blue and green ranges. The bright tablecloth provides a warm contrast.

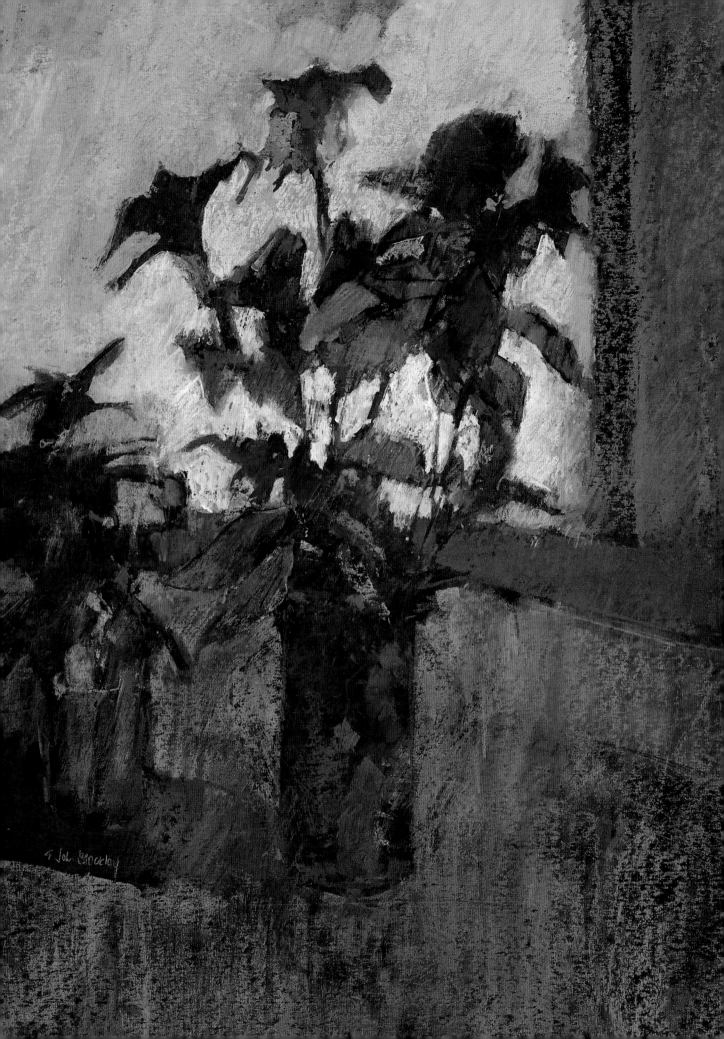

Sketching

Always carry a sketchbook and make sketches frequently. Sketching is an enjoyable experience and helps to cultivate an enquiring mind, while at the same time forming a library of information to draw on for reference when you are painting in pastel back at home.

My sketches shown here are mostly notes made quickly to record things seen and they might well provide information for making pictures in the future. They are not carefully done, yet not carelessly! I love the feel of the pencil travelling over the paper with an almost continuous motion, without lifting off the surface. The act of making a line is one of great enjoyment.

Sketching materials

The pencil is my preferred sketching tool, as it is convenient to carry and immediate in use, but there are other drawing vehicles such as pastel pencil, charcoal, pen and ink, or brush. A piece of sharpened stick dipped in ink or paint gives an interesting broken line.

Sketchbooks are available in a range of sizes. A small cartridge paper sketchbook is handy to begin with, as you can carry it in your coat pocket and use it unobtrusively. Some sketchbooks have a spiral binding, so that you can fold them back. Others have a sewn binding and can be opened out flat for making large sketches across two pages.

▶ In this sketch, I recorded the complex structure of the pit machinery at Blaenavon in South Wales.

▼ A page from one of my sketchbooks, showing Port Isaac in Cornwall.

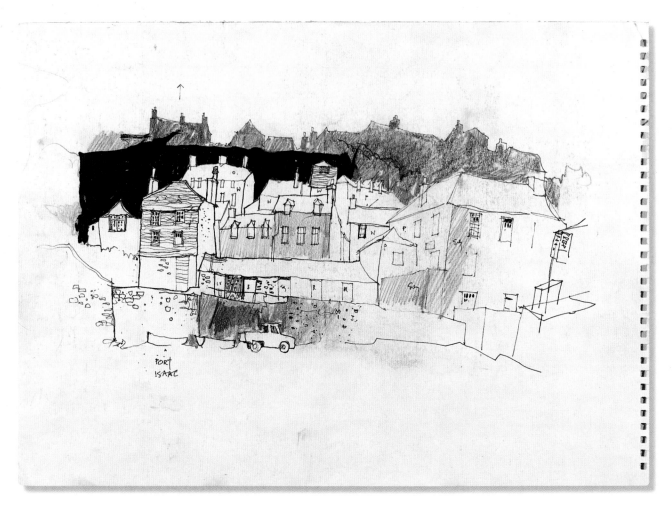

◀ Step 1

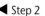

◀ Step 2

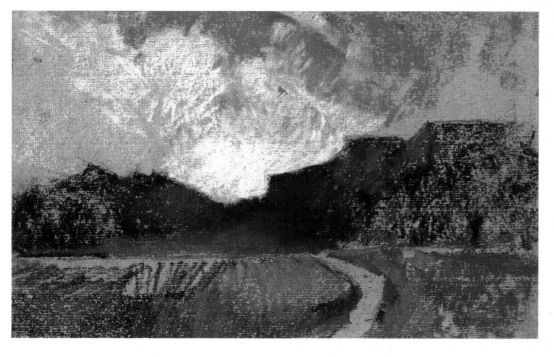

in with Black and White pastel. I then added the mass of sky and foreground.

The hilly landscape above is shown in two stages, so that you can see the progression of pastel marks and colours. I began by drawing the outline of the hills and road, followed by a few strokes of White and Cobalt Blue in the sky to feel my way into the painting. I blocked in some shading on the hills and road with the side of Burnt Umber and Sap Green pastels

(step 1). I finished the painting, using the same colours with the addition of Prussian Blue in the hills and a paler tint of Burnt Umber in the immediate foreground.

I made various marks with the pastel sticks, some of them hatched and cross-hatched strokes and some made with the side of the stick flat on the paper. Parts of the grey paper were left uncovered, mainly in the sky and on the road (step 2).

31

▲ Step 1

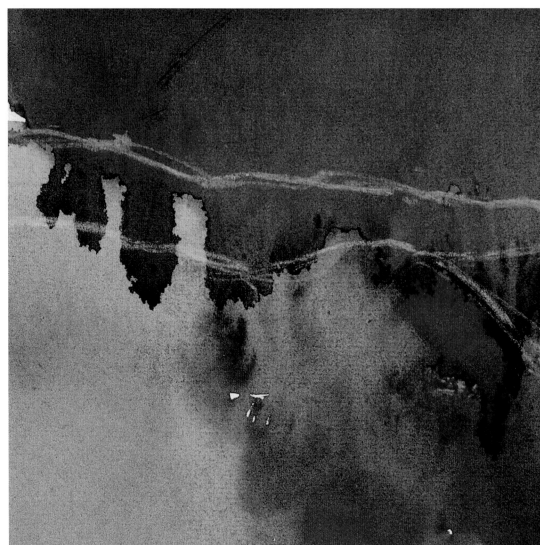

▶ A detail from the
watercolour washes shows
the uncontrolled upwards
spread of ochre.

32

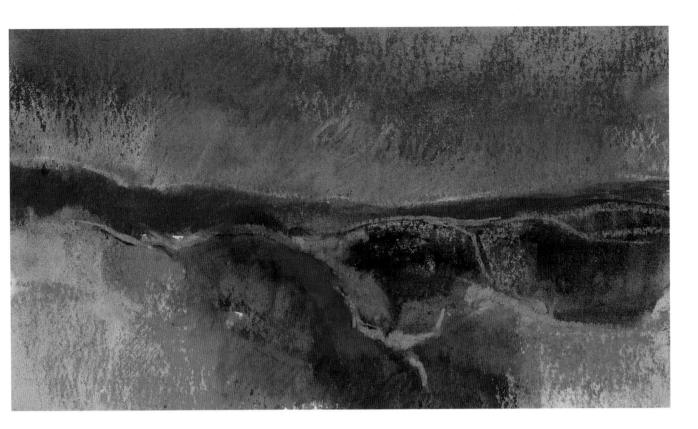

Pastel over watercolour

When composing a landscape, especially those showing distant vistas of hills, woods and meadows, it is often helpful to establish the main areas of colour in advance of the pastel work by laying down washes of paint on the paper. Choose paint colours that echo those of the pastel you will be working on top, so that you create a harmonious effect.

For the painting of trees and rolling hills shown on these pages, I prepared my own surface by covering a piece of watercolour paper with varied shades of watercolour in the same way as for the simple landscape shown on page 16. I mixed a wash of blue watercolour for the sky area and, while this was still wet, I added washes of green, red and ochre to the lower half of the paper (step 1).

At this stage, I made no real attempt to paint a landscape – I just applied the colours quickly without worrying too much about controlling their spread. My main concern was to provide areas of colour to act as a base for the final pastel colours. You will see from the detail (opposite) that the ochre at the left

of the picture has run uncontrolled upwards, but I knew that these runs would be covered when the pastel was applied.

When the watercolour was dry, I indicated a few outlines in white pastel to locate the main contours of the landscape. Then I worked over the painted surface with pastel: blue over blue for the sky, and green over green, red over red, ochre over ochre for the foreground (step 2). In the finished painting, you can see how the pastel marks tone subtly with the watercolour areas underneath them.

Another approach is to start with watercolour washes of colours different from the pastel shades you intend to use. You could work red pastel over green watercolour, yellow over purple or orange over blue. These pairs of complementary colours give exciting, energetic effects.

If you vary the pressure of your pastel strokes, the initial watercolour will break through the pastel to create a vibrant surface. Experiment with this process using the techniques shown in Making Marks, page 18. Try red marks over green watercolour, then add different tints of red or some orange.

▲ Step 2

Weather effects

Wet days, sunny days, atmospheric misty days – the weather has a great influence on the appearance of the landscape, which can change dramatically from one day to the next or even from one hour to the next. My favourite days for painting are at times of impending rain, when skies look stormy, with intermittent bursts of sun breaking through the clouds to create a flash of light across the landscape. Such transitory effects are exciting, giving a feeling of expectancy and offering you the chance to produce an interesting patterned painting.

When painting outdoors on a sunny day, indicate the position of the shadows from the outset, as they will quickly change.

In the painting illustrated on the right, I have taken advantage of the diagonal cloud formation and arranged it to point towards the light area in the distant fields. Such adjustments can lead the eye towards an interesting feature.

Notice that the sky is confined to a narrow strip along the top of the painting, in which the cloud shapes are compressed into a bold pattern of light and dark. The lightest passage is placed in the centre and alongside the darkest part of the sky for impact.

The treatment of the landscape is designed to integrate landscape and sky, so the pattern of fields and trees and the lights and darks are relatively subdued. The dark areas in the landscape echo those in the sky and, to create a further link between sky and ground, a thread of dark blue runs down through the centre of the picture.

Always be aware of such compositional possibilities instead of slavishly copying exactly what is there. In doing so, however, be truthful to the mood of the situation – don't try to be clever and introduce something out of character. I have seen some ludicrous results from doing this, such as shadows going in opposite directions to one another!

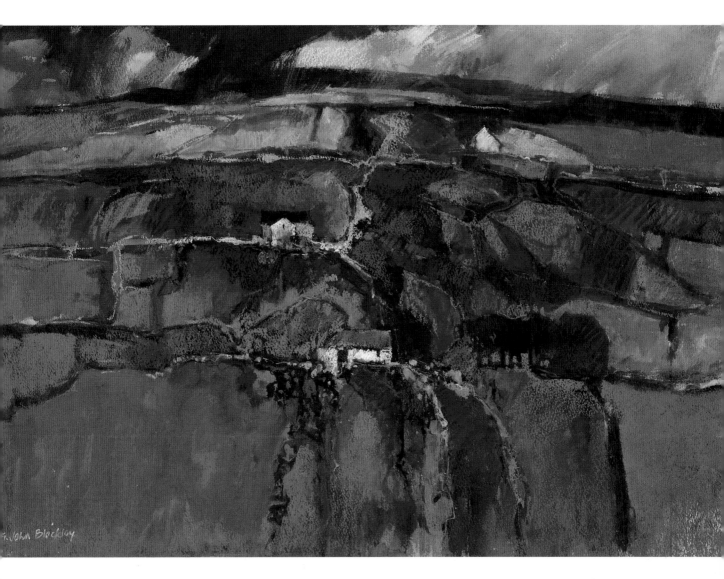

◀ The detail shows how the dark grey paper showing through the pastel marks contributes to the threatening look of the sky.

▲ **Yorkshire Landscape**
44 x 66 cm (17¼ x 26 in)
Dark storm clouds, made with rubbed pastel, give a brooding atmosphere to the landscape.

Cotswold Barn

I have a great interest in old stone buildings and love to draw and paint them in their setting in the landscape. They make wonderful subjects in any situation and I particularly enjoy them when they are silhouetted high up on the skyline or, as in this painting, sitting at the foot of the hills with the ground contours curving downwards and leading the eye towards the barn.

▶ First stage

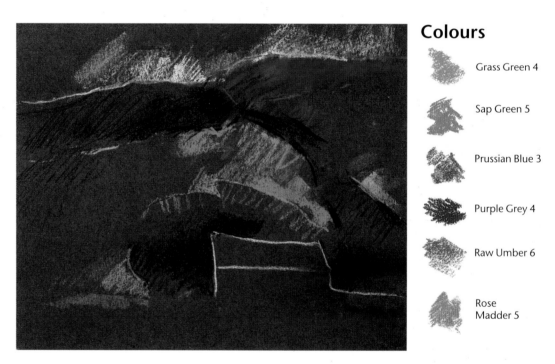

Colours

Grass Green 4

Sap Green 5

Prussian Blue 3

Purple Grey 4

Raw Umber 6

Rose Madder 5

First Stage

I chose a dark green mountboard for the painting. Where a subject is predominantly one colour, it is useful to work on a similar colour of surface. Pick a darker tone than that of the subject – being opaque, a lighter pastel can be painted over the dark surface to give strong contrast. I began by outlining the barn, trees and hills, then indicated the colours appropriate to each part: White for the sky; Grass Green 4, Sap Green 5 and Prussian Blue 3 for the hillside; and Purple Grey 4 for the darker parts of the hillside and trees.

Second Stage

I extended the colours used in the First Stage to describe the various elements in the landscape further, introducing some Raw Umber 6 into the trees behind the barn. To develop an interesting array of marks, I applied the pastel with diagonal strokes, sometimes using the side of the stick. I cross-hatched some of the strokes over one another, and put in occasional dots. The effectiveness of the green mountboard is now apparent and only a few descriptive pastel marks are needed in the final stage.

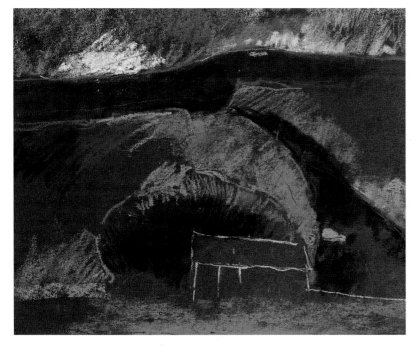

◀ Second stage

Finished Stage

I continued to extend the background colours and then completed the trees with Raw Umber 6. I used Prussian Blue 3 for the roof of the barn; for the walls, I rubbed Raw Umber 6 into White. To complete the barn, I added a touch of Rose Madder 5 to the door. Parts of the mountboard were left exposed to add a further shade of green to the landscape.

▼ **Cotswold Barn**
15 x 20 cm (6 x 8 in)

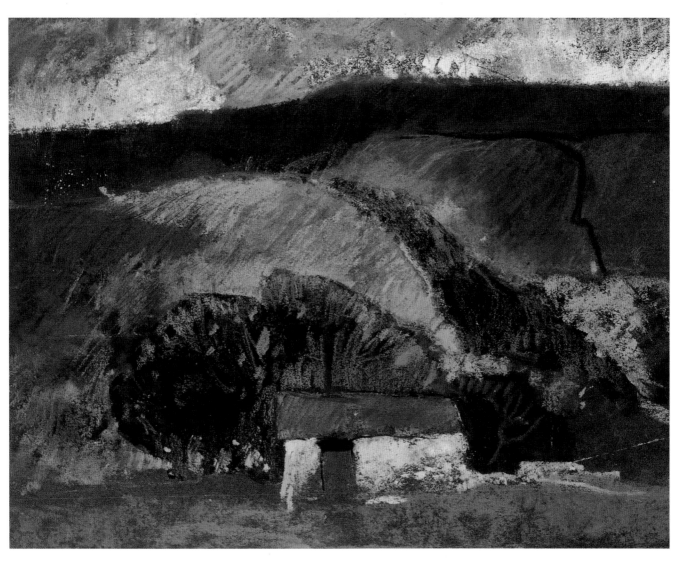

Painting Trees

Trees, portrayed both individually and in groups, are popular subjects in landscape painting and are fascinating in their enormous variety of form, colour and texture. When you are painting a group of trees, try to see them as one big shape rather than as a number of individual trees. Seeing the whole rather than parts of the whole is a way of looking that you should cultivate in your painting generally.

This approach will help you to achieve unity in a painting, as it avoids the work being chopped up and giving an overly busy and detailed effect. By allowing one object to flow into another – for example, by making the shadow of a tree flow from the tree and join another – you will give your painting a sense of continuity.

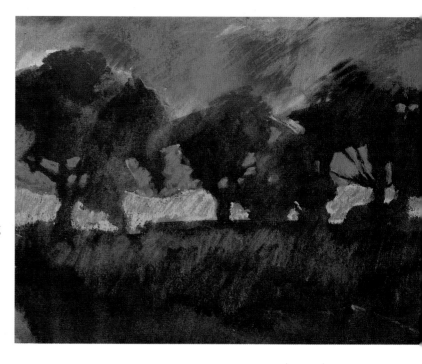

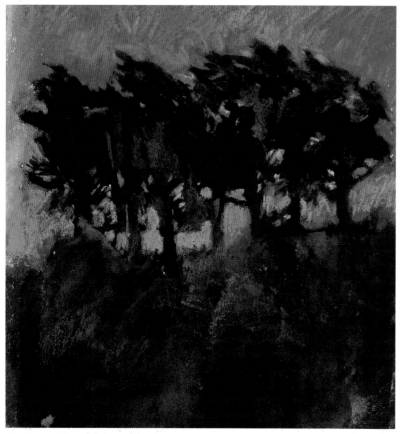

◀ Rather than individual trees being defined, this group has been painted to create a dramatic single silhouette against the vivid orange sky.

▲ In this painting, the trees flow from the dark foreground to form a shape with a fascinating pattern of trunks, branches and foliage.

Looking at shapes

I cannot emphasise strongly enough how important it is to think in terms of shape. It is a painter's way of thinking. Think shapes, and wherever you are, at any time, look for them in your surroundings. Observe how big and little shapes are arranged in patterns. Distinguish between rounded and angular shapes. Notice how some shapes echo others.

Be continually aware of shapes, even if you are just out for a walk and not actually painting. In this way, you will introduce another element into your life and develop a painter's eye for observing objects, relating them and mentally painting them.

Negative shapes

As you observe the shapes in a landscape, you will notice shapes within shapes, such as bits of sky showing through a mass of tree foliage. These are called 'negative shapes' and I love painting them. I am inclined to say that I look at and analyse these negative shapes in preference to looking at the actual shape of a tree. If I get these negatives correct, they will define the tree for me.

Having established the basic shapes of the trees, I then look for changes of colour within them. In a mass of foliage, different greens flow subtly into one another in one continuous movement – a mid-green might gradually change into blue-green or yellow-green, for example.

In the simple sketch shown on the right, I used negative shapes to help me build up the shapes of the branches on the trees. Having first indicated the main outlines of the trees, I looked for the smaller negative shapes of the sky showing through the branches and began to fill these in with white pastel (step 1). By taking the pastel up to the edges of the trunks and branches, I blended the white outlines into the background, leaving the grey paper to represent the trees silhouetted against the sky.

The foliage was added last, the pastel colours blending together to form one big shape that linked the trees together. A few sharper lines of dark pastel were drawn in to show finer twigs on the right (step 2).

Trees will look wrong if their proportions are wrong. Check the relationship between their height and width when you draw them.

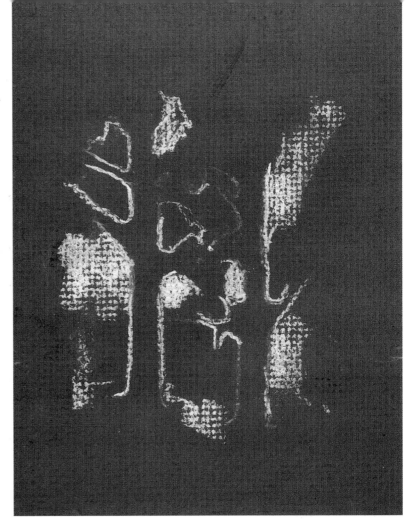

▲ Step 1 ▼ Step 2

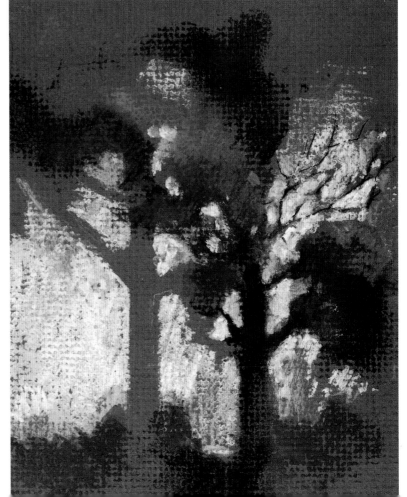

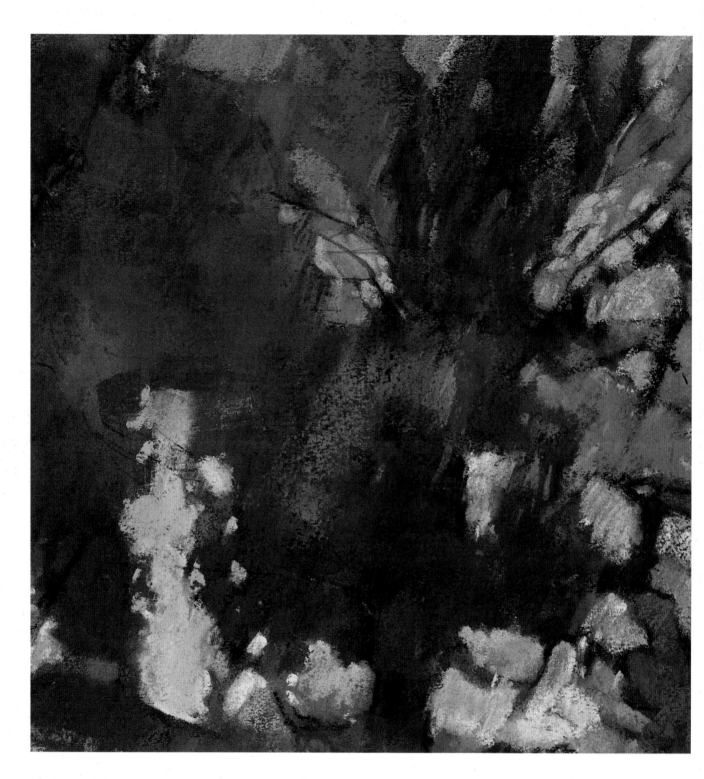

Light and shade

The interplay of light and shade is important when painting trees and looks particularly attractive when trees are grouped together in thickets or woods. Bright sunlight filtering through the mass of branches and foliage creates a dappled effect on the ground and on

▲ The detail shows the colours of the foliage and trunk flowing together to make one shape with subtle tonal variations. Notice the interesting negative shapes created by the patches of light .

▶ **Spring Trees**
71 x 54 cm (28 x 21 in)
Light and shade play a prominent role in painting trees. Here, sunlight seen through the foliage creates a bright area that attracts the eye.

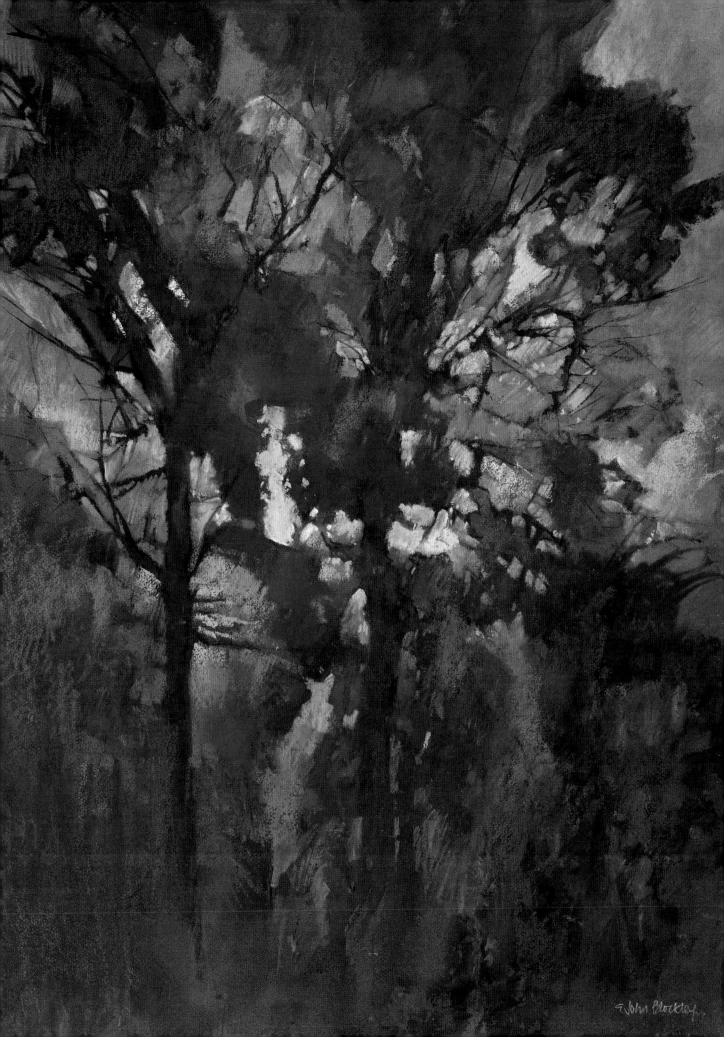

John Blockley

the surrounding trunks. Trees in sunlight throw fascinating shadows, which can be emphasised to play a dramatic role in a composition. The length and position of shadows suggest the time of day, which contributes to the atmosphere of the scene.

How light affects colour

We all know that grass is green, but grass reflecting a blue sky can actually appear to be quite blue. You need to be aware of how a self-colour will look different according to the light falling on it. So observe carefully and paint the colour that you see rather than the colour you know something to be.

Beech trees in certain lighting conditions have an almost silvery look. In the painting below, the beech tree in the centre is illuminated more than those around it. I have interpreted this effect in White pastel with a hint of Rose Madder worked into it. The painting is on blue paper, much of which is left uncovered to represent the darker shapes of the trees in the shade.

How light affects tone

Judging variations of light and shade is important to the painter, who needs to think in terms of tonal values – in other words, how light or how dark an object is. The tone of an

▶ **Beech Tree**
23 x 23 cm (9x 9 in)
The pale, silvery beech tree forms the focal point of this painting, while the darker trees are merely suggested. To give some colour variation to the predominantly blue and white theme, I added hints of green foliage in the background, using Sap Green.

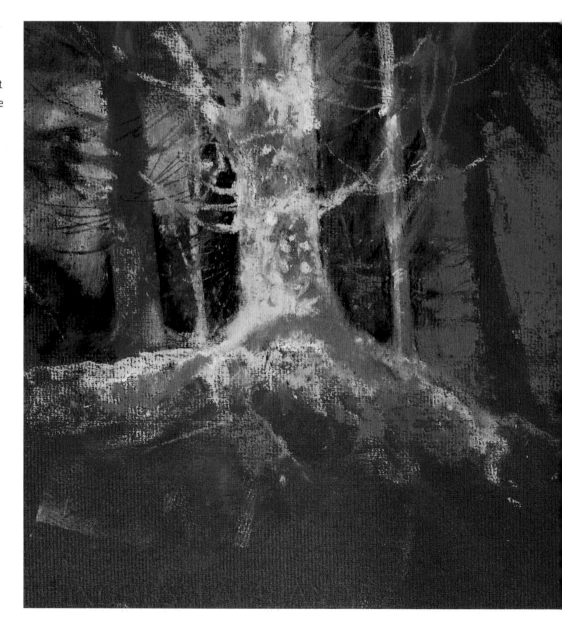

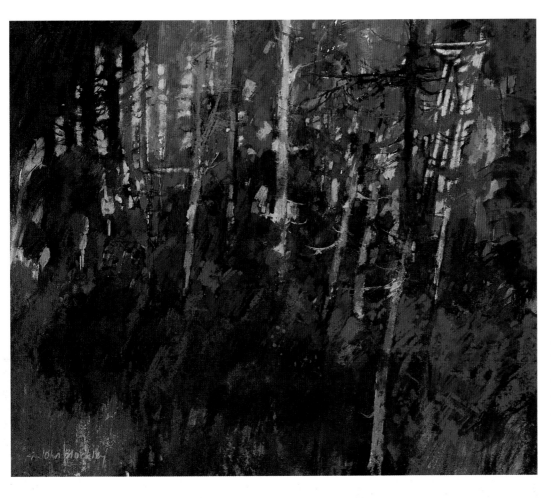

◀ **Autumn**
43 x 51 cm (17 x 20 in)
To emphasise how light affects tone, I painted the tree trunks with light falling on them in pale colours, but left the trunks in the shade as dark, often black, shapes.

object is affected greatly by the amount of light falling on it – the greater the amount of light, the lighter the object will appear. Indeed, a dark-coloured object, such as a black house, in bright sunlight could appear lighter than a neighbouring light-coloured house in shadow. This might sound complicated, but it really amounts to being aware that black is not just black and white is not just white.

Using tonal contrast

Subtle variations of tone will make your work more interesting and your awareness of these subtleties will develop with experience of looking. Probably the most critical thing to bear in mind is to avoid lots of contrasting bits of light and dark in your paintings. When judging how dark or how light to make your pastel strokes, it is important that the viewer's eye should travel comfortably over the painting without lots of distracting, busy changes of tone. Ideally, there should be one

area of principal contrast with all the other tones in the picture chosen to lead the viewer's eye towards this area.

In the painting above, the contrast between the light, bright colours at the top right and the dark tones on the left creates a dramatic composition. I painted the autumn scene on white mountboard, which I totally covered with a wash of black watercolour. I applied the wash quickly with a big brush so that variations of tone occurred, avoiding a perfectly executed flat wash.

I then painted the negative shapes of light sky showing between the trees, using combinations of White pastel and the palest tint of Crimson Lake. I left the preliminary black wash showing for the trees.

Having established the distribution of tree shapes, I modified their blackness in places by adding occasional touches of Blue-Grey pastel. Lastly, I added Prussian Blue to parts of the foreground and Poppy Red for the foliage.

Painting Buildings

Whether viewed close up or seen in the distance, buildings bring interesting shapes and textures into a painting. By contrasting their angular lines with the softer forms of hills and trees, you can use buildings as the focal point of a broader landscape. Set against the skyline, their roofs and chimneys make stark silhouettes.

Older buildings often have wonderfully weathered walls with exciting textures that can be explored with a variety of pastel marks. If you are interested in architectural features, it is rewarding to focus on the details of windows and doors, balconies, decorative mouldings or unusual roof tiles.

Composition

Composition is concerned with arranging the components in a scene in a satisfying manner. The simplest way to do this is to decide which element interests you the most and place it somewhere near, but not exactly in, the centre of the painting. The other components of the painting should be positioned to help draw the eye towards this main interest.

To achieve this focus , you might need to subdue other pleasing features. For example, if your focal point is situated high in the painting, you would need to play down the foreground, however interesting.

Breaking the rules

I saw the farm shown in the painting opposite above the Cornish village of Port Isaac and was immediately impressed by its solid, no-frills shape. Built in pale grey stone, it is set against a backdrop of dark green, almost black trees.

I decided to place the house right in the centre of the painting. It is widely considered that this is bad practice from a compositional

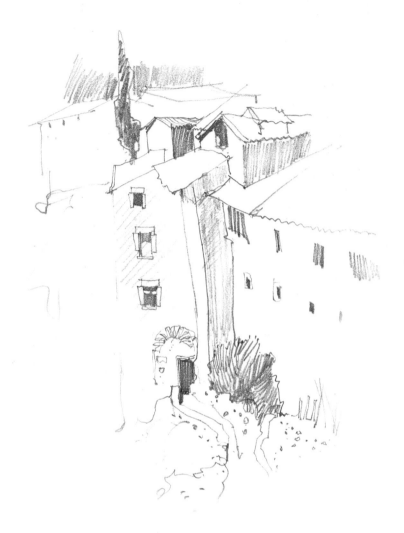

▲ I made this sketch to establish a pleasing composition prior to painting the buildings.

point of view, but although I appreciate this thinking, a perhaps perverse side of my nature enjoys breaking this rule and I like finding a way of nevertheless producing a visually satisfactory arrangement. The long, low building extending outwards from the house, and the trees tapering in the same direction, help to pull the eye away from the centre. The stone wall sloping downwards away from the house also helps.

Because of the mass of dark trees, I decided to paint on black paper. I began by drawing the main outlines with a White pastel pencil. I then put in a few exploratory indications of sky and landscape in blues and greens, leaving black paper to stand for the trees (step 1).

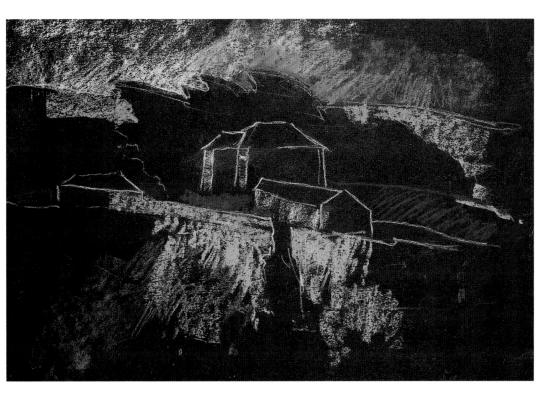

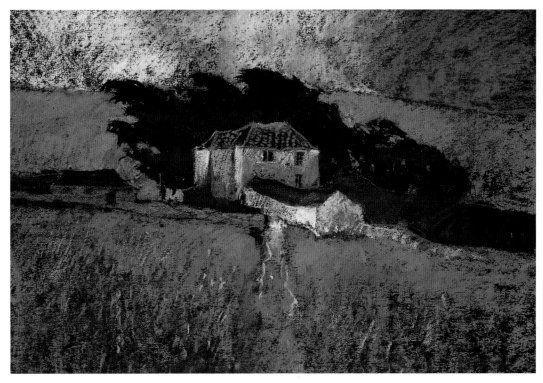

I continued to build up the painting, covering the black paper where necessary and leaving it for the darker parts. I gave the trees an indication of form with some green and developed the house and wall with White and Blue-Grey pastels (step 2).

▲ Step 2

Allotment Hut

This ramshackle hut seemed to have been built from discarded materials – timber planks, corrugated metal sheets and old bricks, randomly painted black with streaks of reddish brown, blue, green and white weathered to pale grey, as though using up half-empty tins of paint. I was attracted by the dark shape of the hut against the pale sky.

▶ First stage

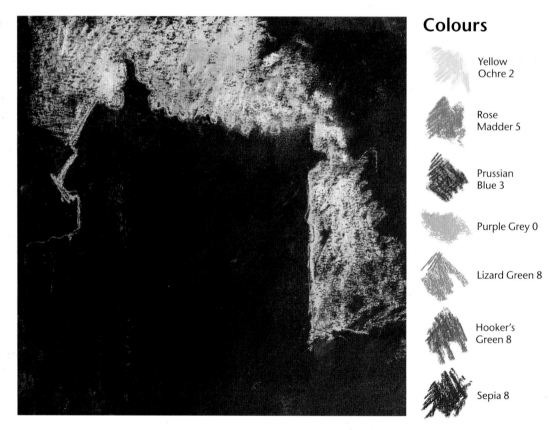

Colours

Yellow Ochre 2

Rose Madder 5

Prussian Blue 3

Purple Grey 0

Lizard Green 8

Hooker's Green 8

Sepia 8

First Stage

I chose black pastel paper and drew the outline of the hut on it. I then started to paint the sky, using Yellow Ochre 2 cross-hatched all over with White. By starting in this way, with the sky surrounding the building, I was able quickly to define its interesting shape with its overhanging corrugated roof and the chimney perched on its highest point.

Second Stage

I now developed the dilapidated but colourful building, adding strokes of pastel pigment to the face of the hut with Rose Madder 5, Prussian Blue 3, Purple Grey 0 and White. Some of the colour was applied in broad strokes using the side of the pastel, some with finer lines using the end of the pastel. I started on the foreground with Lizard Green 8.

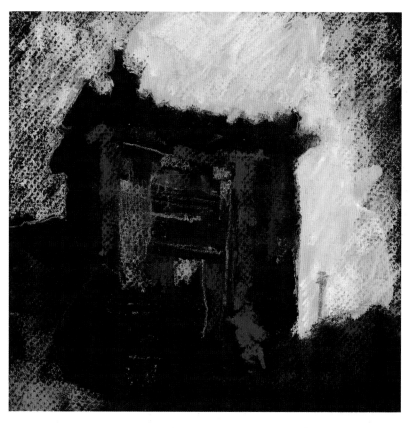

▲ Second stage

Finished Stage

I finished painting the hut, using the same colours as in the second stage. Finally, I completed the foreground with Hooker's Green 8, Lizard Green 8 and Sepia 8. The garden forks shown on either side of the hut were not actually there, but I thought that they were details appropriate to the subject, and they broke up the expanse of pale sky with their interesting shapes.

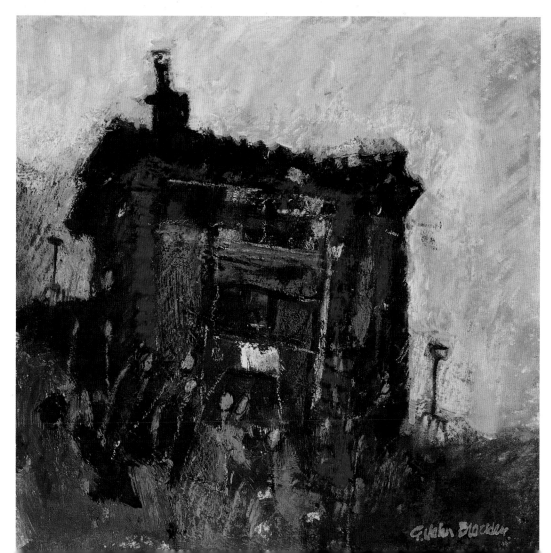

▶ **Allotment Hut**
18 x 18 cm (7 x 7 in)

Evening Stroll, Venice

I painted this scene from a sketch drawn in Venice, when the street was filled with people out for an evening stroll. The sketch was done quite quickly as just a note registering the essentials – the bulk of the buildings, the outlines of the large umbrellas and the people.

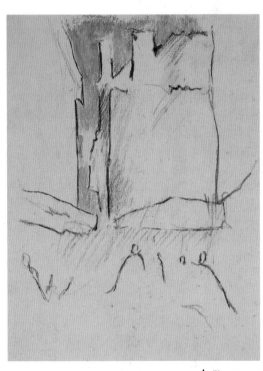

▲ First stage

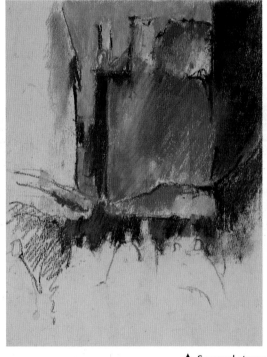

▲ Second stage

Colours

 Olive Green 8

 Madder Brown 6

 Cool Grey 2

 Cadmium Red 4

 Olive Green 0

 Warm Grey 5

 Hooker's Green 3

 Prussian Blue 3

 Burnt Sienna 4

First Stage

I outlined the buildings with an Olive Green 8 pastel, indicating just the main features. Then I marked in the people very simply with a Madder Brown 6 pastel. I blocked in the sky showing between the buildings with Cool Grey 2. This basic first stage is merely a reproduction of my sketch and illustrates how it is sufficient to register a few essentials, especially when drawing surrounded by crowds of people – being watched while working can be very distracting.

Second Stage

So as to enhance the impact of the figures below, I played down the bright hues of the buildings, choosing subdued versions of the colours of the people. For the walls of the right-hand building, I worked Cool Grey 2 over Cadmium Red 4 and Burnt Sienna 4. I rubbed some Olive Green 0 on the wall on the left. The shadow areas were filled in with Warm Grey 5. The roof is Cadmium Red 4 with a little Cool Grey 2. I repeated the colours of the roof and sky in the umbrellas.

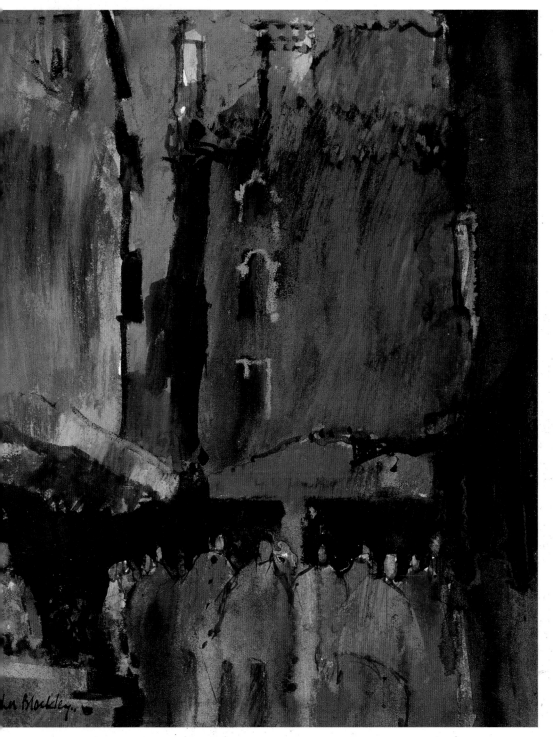

Finished Stage

I completed the buildings by continuing the colours used in the second stage and adding Hooker's Green 3 to the left-hand wall. I indicated roof tiles and windows, then added a building in the centre distance, using Prussian Blue 3. When colouring the figures, I made one of them blue to echo this blue building; others picked up the reds and orange of the building on the right with strokes of Burnt Sienna 4. I painted the figures almost as caricatures with bulbous forms to contrast with the rectangular buildings above. Their heads, all in a row, are merely ovals of Cadmium Red 4, simply treated with no attempt to show features.

Painting decorative windows

I have always been interested in the architectural details of old buildings and find windows particularly fascinating, especially the decorative styles with shutters and balconies. During a trip to Venice, I enjoyed exploring the back streets and found enough beautiful architecture to provide me with inspiration for a long time.

Venetian windows

Venice is all about colour, with houses painted terracotta, dark green, pale green, blue and cream. Their walls frame symmetrical rows of windows stretching along the waterfront. There are many designs of window, often with flamboyant rounded or ogee arches and ornate tracery.

I liked the contrast of the dark shapes of the windows against the colours of the houses

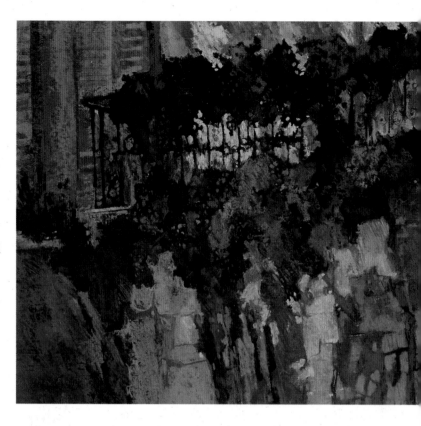

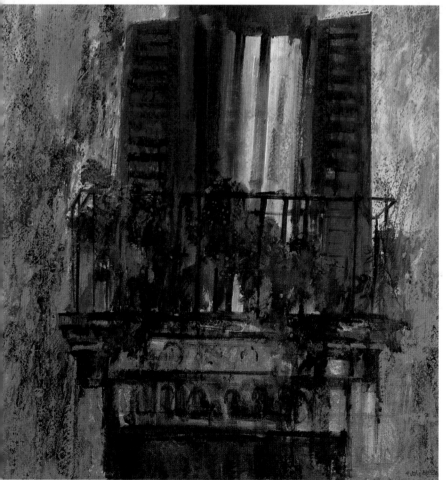

▲ **Balcony Flowers**
35 x 43 cm (13¾ x 17 in)
This balcony carried boxes of bright flowers along its top rail. The flowers cascaded downwards to join more flowers along the top of the wall. I enjoyed painting the blue shadows against the almost lemon-coloured stone wall.

◄ **Windows with Shutters**
84 x 84 cm (33 x 33 in)
This was an interesting viewpoint looking up at the window, so that in perspective it tapered away from me. This tapering effect is of great importance to the painting, and is much more arresting than a straight-on view.

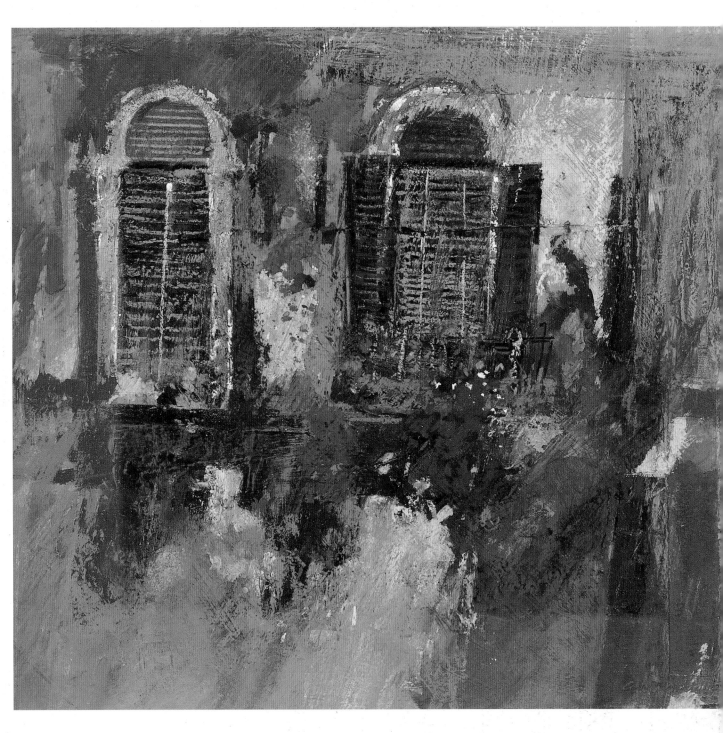

and I especially enjoyed making close-up paintings of windows with interesting features. I was attracted to the picturesque windows shown on these pages. The two windows opposite have metalwork balconies holding pots of flowers, while the pair shown above have window boxes. The windows all have slatted shutters, which enclose and emphasise them when open or hide them with their horizontal slats when closed.

▲ **Windows, Venice**
36 x 33 cm (14¼ x 13 in)
The main interest here was the colour and light falling on to the wall surrounding the windows. It was so attractive that I deliberately exaggerated it to create a colourful and vibrant work. In order to emphasise the strong yellow and red of the walls, I painted the shutters, blinds and flower boxes in dark, subdued colours. I also kept the flower boxes free of detail, putting only a hint of white flowers in the right-hand one.

Cottages, North Wales

My immediate interest on first seeing this row of cottages was the outline that the black roofs and chimneys made against the pale lemon sky. The white walls of the cottages make an eye-catching contrast with the black roofs, and so I concentrated the white in one area to emphasise this feature.

▶ First stage

Colours

Purple Grey 0

Grass Green 1, 4

Ivory Black

Prussian Blue 3

Raw Umber 6

Blue Green 5

First Stage

I chose a deep grey pastel paper and drew the principal lines of the buildings with Black pastel pencil. I added a few indications of the walls with White and Purple Grey 0 pastels.

Starting on the sky, I cross-hatched Grass Green 1 over White. I then moved on to the row of roofs, shading them with Ivory Black and a few hints of Prussian Blue 3 and Blue Green 5. In the foreground, I began using Grass Green 4 with the two blues.

At this stage I was feeling my way into the painting, so I was careful not to complete any one part of it. The process was exploratory, allowing me to change colours if necessary before continuing with the painting.

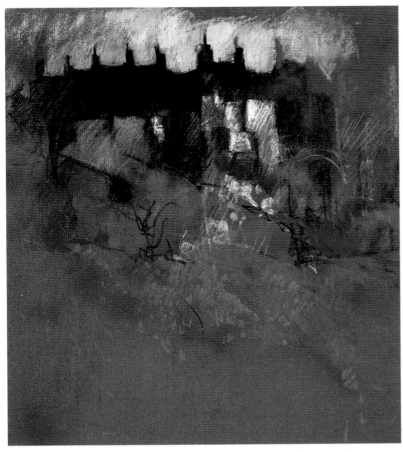

◀ Second stage

▼ **Cottages,
North Wales**
38 x 36 cm (15 x 14 in)

Second Stage

With the choice of colours now established,
I continued with them, working across the
whole painting to keep it moving towards the
final stage. I warmed the foreground in places
with Raw Umber 6.

Finished Stage

I developed the painting with the previous
colours, adding Prussian Blue 3 to suggest
shadows on the houses. To add interest to the
foreground grass, I put in textural marks in a
mix of blues and green. Finally, I defined
details, such as windows, the stone-built wall
and the tree branches.

 Notice that the foreground occupies more
than half the picture area. This serves two
purposes – it makes the buildings look
important high up and provides a large area
of texture below them. The white on the
houses is confined to one spot to give a point
of impact. This is more arresting than making
all the buildings equally white.

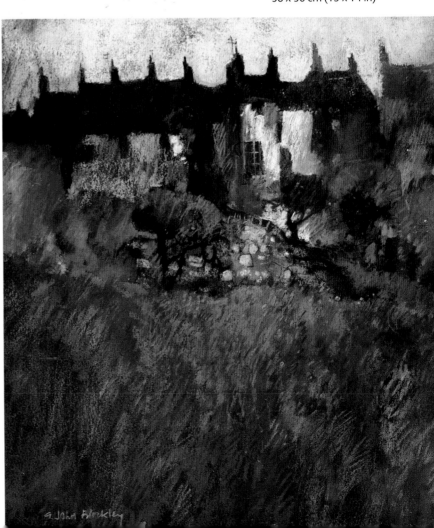

Wall textures

Pastels are excellent for describing textured surfaces (see Making Marks, page 18). By cross-hatching one colour over another, combined with broad sideways strokes, stippling and drawing with the end of the pastel, you can obtain exciting effects. Interesting contrasts can be achieved by placing areas of texture and vibrancy against quieter areas.

The textures of old buildings offer good potential for painting with pastel. Stone-built buildings, weathered brick, timber – all have wonderful surfaces. Lichen-covered walls, peeling paint or wood with a pronounced grain weathered to silvery grey are also very rewarding to paint.

Walls in towns and cities

Towns and cities offer wonderful possibilities for painting wall textures. Brick is a common building material for houses in towns. Some artists might attempt to paint every brick and show every mortar joint, but I prefer to use a broader treatment, dragging a pastel stick sideways across the paper. With a textured paper, random textures result where the grain shows through the pigment.

Pebbledash, a rough wall finish often seen in suburban streets, requires a different treatment to brick. Cover the surface of the wall with a creamy colour, then develop it by stippling over it with the end of a light grey or brown pastel. Some of the stippled marks could be left pronounced, while others could be softened with a finger.

Modern buildings offer further challenges. They are often built of shiny, reflective materials and have large expanses of glass. These features suggest flat areas of smooth, rubbed pastel with an overlaid pattern of reflected shapes.

Patterns in lettering

In towns and cities, I am excited by walls with pasted-on advertisements, sometimes torn to reveal the surface underneath These, as well as shop signs, show different types of lettering – some small, some big and chunky, some plain and others ornate.

I saw the run-down houses shown in the painting opposite in Islington in London. Not only were they interesting because of

▼ Detail of graffiti

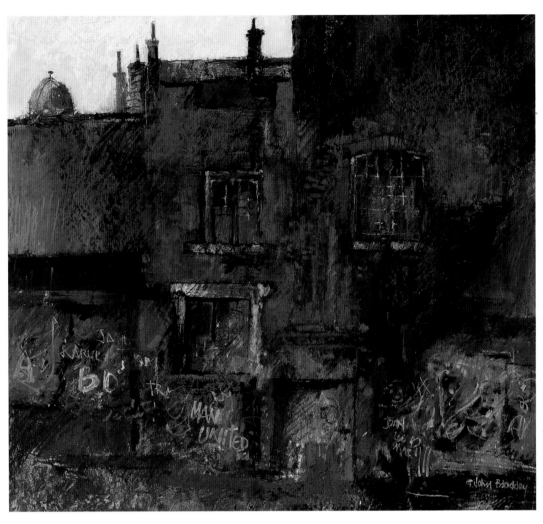

◀ **Red Brick with Graffiti**

48 x 53 cm (19 x 21 in)
In this composition, the plain upper parts of the walls contrast with the busy effect created by the graffiti.

the textures of old red brick and peeling paintwork, but they were also covered with graffiti, which introduced a patterned element to the lower part of the buildings. I enjoyed the freedom of making these swirling pastel marks.

The subject also appealed to me because of the way in which the large upper area of relatively quiet, warm red brick contrasted boldly with the cooler, textured blue and green painted area below. The blues and greens are echoed in the windows above, which provide a unifying link between the two areas. This arrangement of distinctive blocks of colour has an almost abstract feel.

The colour of the sky was carefully considered. I did not want to use the actual blue of the sky and decided that a pale lemon colour would work well with the rest of the composition.

When painting lettering on a distant wall, poster or shop sign, it is enough just to suggest the forms of the letters. Don't attempt to put in every detail.

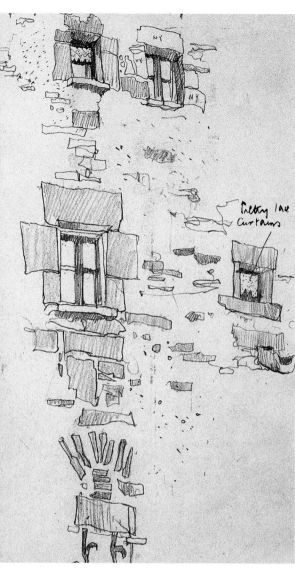

◀ In this sketch, I began exploring the textures of the wall shown in the painting opposite, focusing on a small area.

▼ The detail shows how I achieved the colourful, rough-hewn look of the wall with blocks and layers of pastel.

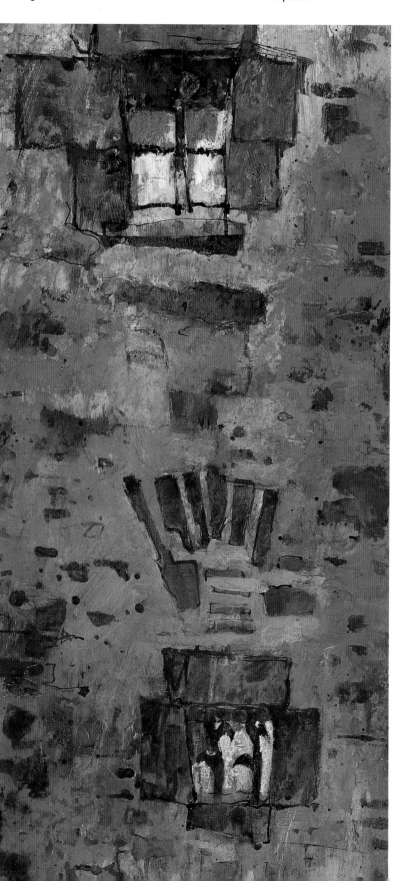

Stone walls

The rough texture and golden colour of the house wall is the main feature of this pastel painting. I worked it in the studio from drawings made with my painting group in the village of Rupit in Catalonia, Spain – a fascinating place with twisting, cobbled footpaths and a profusion of flowers.

I was particularly attracted to the unusual architectural details and random stone construction of the houses. The stones varied from thin slices to huge blocks, and there were delightful colour accents of terracotta sandwiched in the walls. Small windows were enclosed by big slabs of stone and many of them were protected with decorative hand-forged metal grilles.

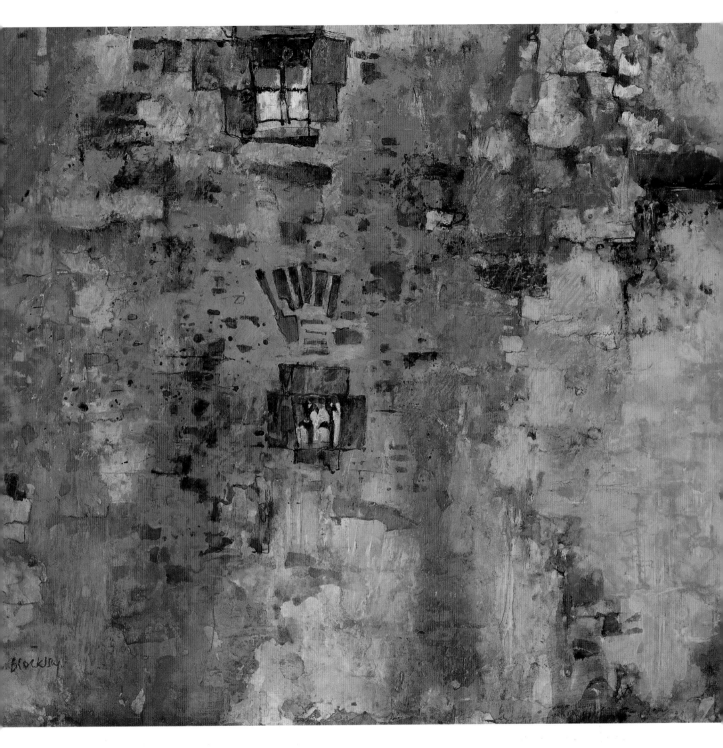

The whole village was full of texture and colour, and I spent many hours sitting on the roadside just drawing areas of wall such as the piece shown above. This painting started with random washes of watercolour on white mountboard. I allowed the colours to touch and blend together to give a variable creamy colour with suggestions of pink, orange and brown. Then I applied pastel in the same colours, but slightly different in tone, some lighter and some darker than the watercolour base. The windows were added last.

The stones range in size from dots of Sepia pastel stabbed on to the painting with the end of the pastel to rectangular blocks made with the side of the pastel. I have shown relatively few of the stones, leaving large areas of the creamy background untouched.

▲ **Stone house in Rupit, Catalonia**
44 x 37 cm (17¼ x 14½ in)
Washes of watercolour under the pastel marks give depth and subtlety to this textured wall.

Painting Flowers

Flowers are an exciting subject to paint – their freshness and vibrancy call out to be captured with the pure colour of pastel pigment. If you feel daunted by the mass of detail you can see in an arrangement of flowers, remember that the key to success is to simplify. Try to see flowers with a painter's way of looking. You are not aiming to produce a botanical illustration correct in every detail, but rather to convey your personal reaction to the beauty of the flowers before you.

A useful trick is to look at the blossoms through half-closed eyes, allowing petals and flower heads to merge together to form a single mass. Within this mass, the overall patterns of colour, light and dark become more evident and are easier to put down on paper. Particularly strong highlights or contrasting colours will stand out and provide bright accents in the composition.

Pastel strokes for flowers

Many painters of flowers are concerned with producing a smooth, realistic rendering and often achieve remarkable results, even capturing the sheen on the petals. These effects are produced by rubbing the pastel strokes delicately with a finger.

The flowers shown on these pages were treated in a more robust way with unrubbed pastel. With this treatment, fragments of pastel cling to the surface of the painting and

▼ **White Flowers**
51 x 61 cm (20 x 24 in)
This is an impression of white flowers, reflecting some of the surrounding red colour in places. The foliage and the red background are slashed in with broad strokes, with occasional decisive lines of black to firm up edges.

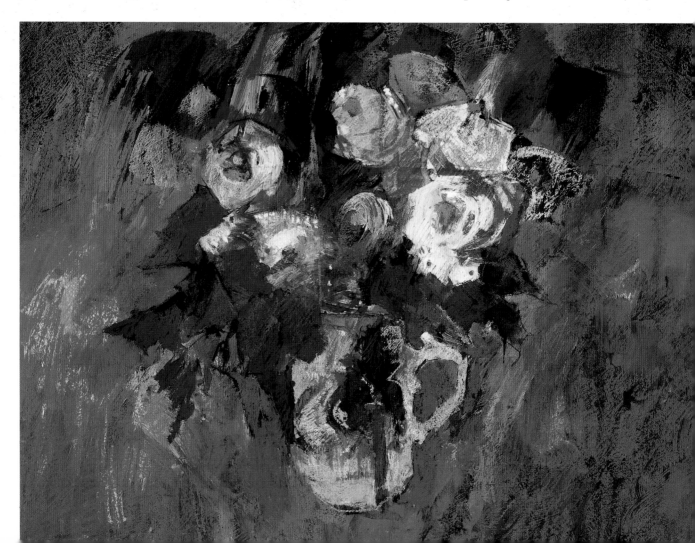

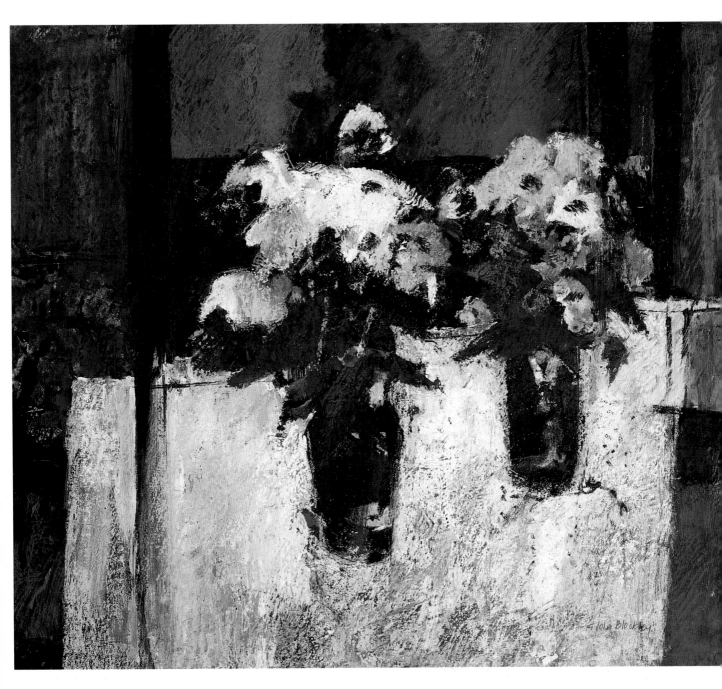

reflect light falling on them. I enjoy the feeling of light bouncing off the flowers and pastel is extremely capable of conveying this effect.

Colour combinations

One way of thinking is that, to be truthful to the subject, a painting should reproduce the actual colours of the flowers. Another argument is that artists should make their own interpretation. In the painting of two flower vases shown above, I used the white

flowers as a starting point from which I decided on my own colour combinations.

I chose to repeat the white of the flowers for the tablecloth and painted the vases and background black to give a strong contrast and to emphasise the flowers. I decided to use red at the top and sides of the painting to provide strong, attractive colour against the monochromatic black and white. So, I have been truthful to the actual colours of the flowers, while altering the other colours in the subject to meet my requirements.

▲ **Two Flower Vases**
46 x 53 cm (18 x 21 in)
The colour arrangement in this work is carefully considered, creating a strong, positive painting.

Flowers on White Cloth

I love painting flowers as a way of recording my personal reaction to their brightness and the way they reflect light. I aim for an impression, the sensation of the first glimpse, the first impact, rather than a detailed analysis of their construction.

▶ First stage

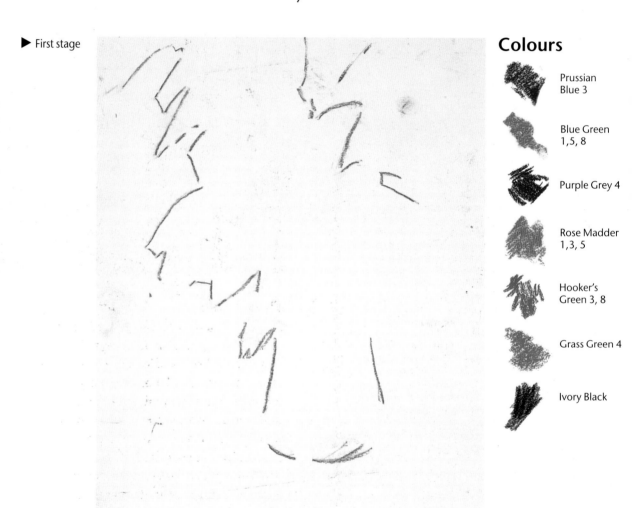

Colours

Prussian Blue 3

Blue Green 1, 5, 8

Purple Grey 4

Rose Madder 1, 3, 5

Hooker's Green 3, 8

Grass Green 4

Ivory Black

First Stage

I chose white conservation mountboard for this picture – it has a smooth surface, which is unusual for pastel work, but I often prefer it. I drew a sketchy outline of the flowers and vase with Prussian Blue 3 pastel, putting in just enough lines to act as a guide for the watercolour washes to be applied next.

Second Stage

I did some preparatory work by applying washes of watercolour all over the board, choosing colours that would provide an appropriate base for the pastel work that I would be starting in the third stage. To begin with, I put in a very dilute wash of Crimson Alizarin watercolour in the area that would be

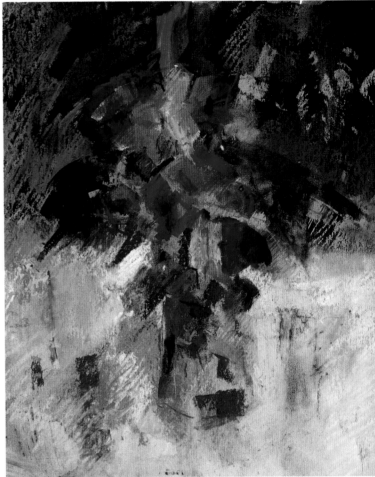

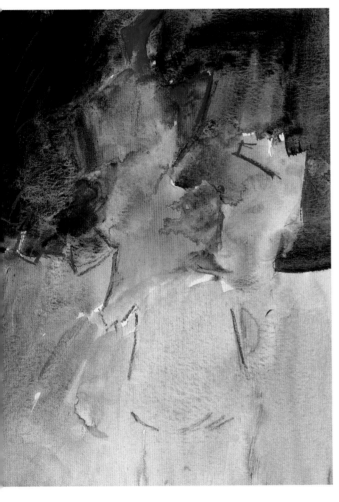

filled with the pink flowers. I chose Lamp Black watercolour for a background wash that would break through and give texture to the pastel overlay. A wash of Hooker's Green watercolour gave a suitable base for the range of green pastels to be used in the leaf areas, and Cobalt Blue watercolour provided an extra shade of blue in the foreground.

Third Stage

I began by applying Prussian Blue 3 pastel over the background in order to establish the shape of the flower and leaf areas more firmly. I used the pastels with positive, energetic movements in a predominantly diagonal direction, allowing some of the Lamp Black watercolour to show through to give a decisive feel to the work.

Then I applied pastel over the foreground cloth, again in a very positive manner, using strokes of Blue Green tints 1, 5 and 8, White and Purple Grey 4. The treatment of the cloth was repeated in the vase, so that the two flowed together. I added colour to the flowers, using Rose Madder tints 1, 3 and 5. Colour accents in the vase echoed those of the flowers. Finally, I used Hooker's Green tints 3 and 8 for the leaves, jotting in a few touches of Grass Green 4 and Ivory Black to give colour and shadow within them.

Finished Stage

To give a little more definition to the patterned cloth, I added dashes of Rose Madder 5 pastel. I tried to produce just a hint of a patterned area rather than a definite pattern that would compete with the flowers.

Returning to the flowers and leaves, I developed tonal contrast by using White and pale tints of Rose Madder and Hooker's Green for the highlights, and dark tints for the shadow areas. Notice how I built up texture with a variety of marks – cross-hatching, dots, flat strokes – to create a profusion of colour without specific definition.

▶ **Flowers on White Cloth**
56 x 51 cm (22 x 20 in)

▲ Detail of the flowers

▶ Detail of the cloth and vase

62

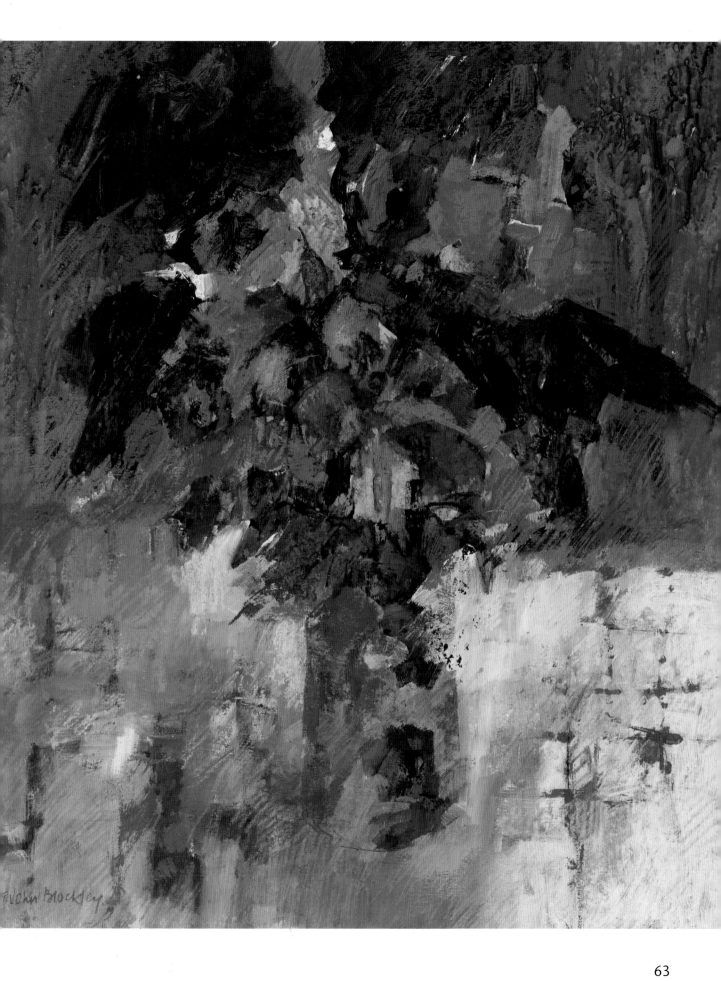

And Finally...

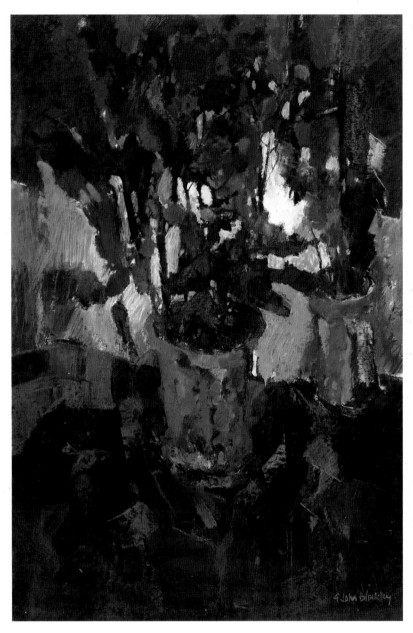

◄ **Flowers on Patterned Cloth**
74 x 21 cm (29 x 20 in)
In this composition, the rich hues of the flowers are repeated in the patterned cloth and the background blue echoes the colour of the vase.

I hope this book has whetted your appetite and encouraged you to become more involved in painting with pastel. For many of us, painting is a way of life – seeing the world in new ways and seeking fresh ideas. There will be both disappointments and successes, but with growing experience, you will find yourself part of a painting community of fellow artists, who enjoy sharing ideas and taking an interest in each other's work.

You should, of course, practise techniques and make pictures, but it is vitally important to widen your scope by communicating with others. You can't work in isolation. Visit exhibitions, join your local art club and enjoy the exciting medium of pastel.